THE TIME BY THE SEA

In a long and distinguished career Ronald Blythe's work includes *Akenfield*, his classic study of English village life, poetry, fiction, essays, short stories, history and literary criticism. His work has been filmed, widely translated, awarded literary prizes and his 'voice' recognised as one of special originality. Blythe is President of the John Clare Society and has always taken part in the cultural life of his native countryside. He lives in the Stour Valley in the farmhouse that was once the home of his friend John Nash. *The Time by the Sea* was shortlisted for the East Anglian Book Awards 2013.

Further praise for *The Time by the Sea*:

'A beautiful recollection of Aldeburgh in the 1950s.' David Martin, *TLS* Books of the Year

'Blythe, mostly known for *Akenfield*, his study of English village life, is the best possible voice to capture the charming but eccentric town of Aldeburgh . . . Vignettes . . . of Britten and his fellow festival artists are very appealing, and Blythe tells them brilliantly.' Ella Swift, *The Lady*

'Read it as a diary of the Suffolk and Essex countryside. Read it as a portrait of a hardy gang of postwar pastoralists whose creative careers worked themselves out almost completely in the shadows. Read it as a reminder that writing about working-class rural life needn't be mawkish or twee. But read it above all as a supreme study of a life adrift.' *Literary Review*

'Far more than a cultural reminiscence . . . it's a vanished world miraculously brought to life by poetic prose.' *English Home*

'Blythe's memoir is full of pleasing vignettes . . . but *The Time by the Sea* is, above all else, about learning to be a writer.' *Oldie*

by the same author

The Age of Illusion
William Hazlitt: Selected Writings
Akenfield
The View in Winter
Writing in a War
From the Headlands
Divine Landscapes
Private Words
Aldeburgh Anthology
Going to Meet George
Talking about John Clare
First Friends
Field Work: Collected Essays
A Writer's Day-book
The Circling Year
Talking to the Neighbours
Aftermath: Selected Writings 1960–2010
The Word from Wormingford series

FICTION
A Treasonable Growth
Immediate Possession
The Assassin

RONALD BLYTHE

The Time by the Sea

Aldeburgh 1955–1958

ff

FABER & FABER

First published in 2013
by Faber and Faber Ltd
Bloomsbury House
74–77 Great Russell Street
London WC1B 3DA

This paperback edition first published in 2014

Typeset by Agnesi Text, Hadleigh, Suffolk
Printed and bound in the UK by CPI Group Ltd, Croydon, CR0 4YY

A CIP record for this book
is available from the British Library

ISBN 978–0571–29095–6

FSC
www.fsc.org
MIX
Paper from
responsible sources
FSC® C013604

6 8 10 9 7

For Vicky Minet

Contents

List of Illustrations ix
Map xi

 1 Fairhaven 1
 2 Morgan 17
 3 Travelling with Julian 29
 4 How I Came to Wormingford 41
 5 Fidelity 67
 6 Meeting Ben 77
 7 Blythburgh 97
 8 Imo 107
 9 Staverton 127
10 At 36 Crag Path 137
11 At Strafford House 153
12 At the Uplands 167
13 My Guru 177
14 Sleeping in the Moot Hall 187
15 At Benton End 199
16 Mr FitzGerald is in the Wood 211
17 The Airfield 225
18 The Sea 233

Selected Personalia 241

Bibliography 245

Index 247

'Very Quiet Here' by U. A. Fanthorpe, reproduced by
permission of R. V. Bailey; letter from Rosie Bailey to
Nigel Weaver, reproduced by permission of R. V. Bailey;
E. M. Forster, *The Hill of Devi* (1953), reproduced by
permission of The Provost and Scholars of King's
College, Cambridge, and The Society of Authors, as
the E. M. Forster Estate; David Gascoyne, 'Sentimental
Colloquy' from *A Vagrant and Other Poems* (1950),
reproduced in *New Collected Poems* (Enitharmon Press,
2013); Benjamin Britten's note on *Simple Symphony*
reproduced by permission of The Britten–Pears
Foundation; quotations from the diaries and other
writings of Imogen Holst reproduced by permission
of The Holst Foundation; and quotations from the
writings of John and Christine Nash reproduced
courtesy of Ronald Blythe, Trustee of The Nash Estate.

Every effort has been made to trace or contact all
copyright holders. The publishers would be pleased to
rectify any omissions or errors brought to their notice
at the earliest opportunity.

List of Illustrations

1 Ronald Blythe at Thorpeness, 1955
2 E. M. Forster
 Photo Kurt Hutton
3 John Nash: *Sea Holly*
4 John Nash at Bottengoms
 Photo Russell Westwood
5 Fidelity Cranbrook with the Gathorne-Hardy
 children featured in *Let's Make an Opera*
6 Peter Pears and Benjamin Britten shopping
 in Aldeburgh High Street
 Photo Kurt Hutton
7 An angel boss in Blythburgh Church
 Photo Leslie Marr
8 Imogen Holst conducting
 Photo Gerald Style
9 John Nash: *Staverton Thicks*
10 The Hutton family at 36 Crag Path
 Photo Kurt Hutton
11 Edward Clodd
 Portrait by John Collier
12 Extract from *Records of the Borough of Aldeburgh:
 The Order Book 1549–1631*
13 James Turner, 1951

14 The Moot Hall, Aldeburgh, 1924

15 Sir Cedric Morris at Benton End

16 Ronald Blythe at Great Glemham
 Photo Kurt Hutton

17 James Hamilton-Paterson
 © Belgrave Press Bureau

18 John Nash: *Aldeburgh Beach*

Line drawings by John Nash are taken from the 1956 Aldeburgh Festival Programme Book. Photographs are reproduced courtesy of Ronald Blythe.

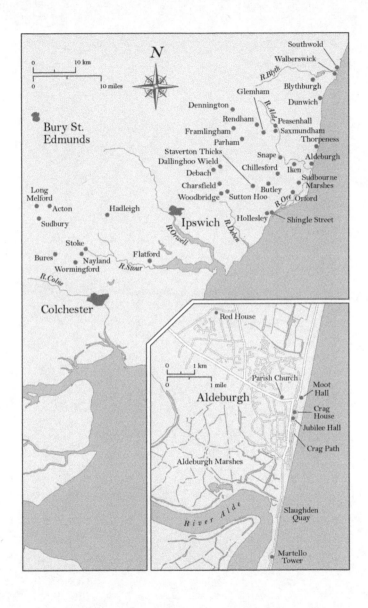

Listening has been a large part of my craft. It was William Sansom who used to give 'Watching' as his hobby in *Who's Who* and it is true that writers are as watchful as cats. But what of listening? Or is listening an integral part of watching? I would like to isolate listening from the writer's general function of obsessive observation and ask, do we, as poets, novelists and historians, ever attempt to examine or assess our own individual ear? Have we any idea of the range of our listening or of its selectivity? We know that we have long since become quite unashamed about our eavesdropping and we know that there is a subtle difference between what we set out to hear for the purposes of literature, and what we hear involuntarily. But what we do not know is the extent and pattern of our listening generally. It seems easier to describe what we normally *see* than what we normally hear. Even in the physical sense we allow the eye ranges and limitations which, unless we suffer from very considerable loss of hearing, we deny to the ear. Yet it is likely that the solitary nature of the act of writing, and the accumulative quiet in which most of us spend our working lives, affects our listening capacity, intensifying it in some, distorting it in others.

Listening in the strict sense of the word means to hear attentively. Yet literature abounds with remarkable things which the writer heard because he was *not* paying this kind of classroom attention, and by this I do not mean inner voices and the like, but actual sounds, usually sentences, floatingly acquired. Those speaking these sentences, did they but know that they were being so effortlessly intercepted, could say, 'I am not talking to *you!*' But as every writer knows at such a moment, they are! – and in riveting tones. His thoughts build up around these syllables which he could have missed had he been listening 'attentively' and his creativity comes into play.

1 Fairhaven

Setting down the first words of a first novel was not unlike putting a toe in the North Sea when the weather warmed up. How far dare I go? There was a page of Quink then a page of Olympia typewriter letters. I saw that I was methodical if nothing. This novel I decided would be Forsterian or possibly Bowenesque, and carefully unoriginal. Its lovers would be ambiguous, needless to add, and confused about the approaching war, which, like Dylan Thomas, they would regard as a personal inconvenience. They would live in a thinly disguised Aldeburgh, lie to their mothers, tentatively explore each other's bodies and emerging characters, and take a long time to grow up. You were not adult until you were twenty-one in 1939. For my anti-war hero siren voices would whisper literature, creating unrest and malcontentedness. Voices which had no idea what her hormones were telling her would confuse the girl. They got along fairly smartly on the typewriter but were often held up by a short story which had to be written that minute and posted off to the *London Magazine* or *Chamber's Journal.* Very short stories were sent to V. S. Pritchett at the *New Statesman.* But this was in the near future.

The Now was a winter bungalow at Thorpeness on the Suffolk coast still littered with holiday reads. I picked them up where they fell. I took *Indigo* to bed. Its colourfulness warmed me up. It was of course about racism, love and cruelty, a theme which I reset in Suffolk. I wondered who Christine Weston was and how surprised she would be to know that her novel had somehow collided with my loneliness and first sentences. *Indigo* sprawled on the floor in the sea-deafening night that January week as I lay cocooned in Mrs Foljambe's pitch pine, a gaudy tale left behind in summer. I read it in small snatches with the waves thumping the shingle for my attention. I had never slept so near to the sea before, not even in Cornwall. It was marvellously monotonous and apparently safe, unable to make the few yards to where I lay, a sea on a cosmic leash, rushing at me then pulled back. Yet it sucked at my pillow and clinked its shingly trinkets at my ear. It bayed and hissed and implored, and would do so for ever. I felt it dragging my new purpose from me. I told it, 'Wait until after breakfast and then you can have me, gale or no gale.'

The snow had stopped then. There was fretted ice-spray all along the shore and the tide was lapping away at the ruined defences in a friendly manner. Safe in my duffel coat and yards of knitted scarf, I plodded along the bitter sand in the direction of Sizewell, instantly frozen but excited. It was cold beyond belief. I collected

bits of painted boat and other driftwood to dry out in the shed. There were, I was told later, lumps of South-wold pier and future fuel from as far off as Norfolk, all waiting to make a blue salty blaze in the Delft grate. And I went on reading *Indigo*, sensing that it was there for some purpose as yet unknown, though time would tell. The sealed plate-glass 'solar', as Christine Nash enviously called it, warmed up at the merest touch of the sun whilst everywhere else stayed frigid. The Anglo-Indian novel complemented not only this Anglo-Indian house but in some strange way, since I had never been to India, something in myself. This is what fiction does.

The corrugated tin on the station roof cracked from accumulated heat and a variety of smells and sounds escaped from the population which milled on the platform. Threading this polymorphous mass were the usual complement of starving dogs and sidling women. The hot breath of the train and the steaming breath of humanity rose to a blue heaven where the everlasting kites wheeled and circled.

Hardyal stood beside his father; his heart was beating violently, his smile was fixed, great tears kept rising and subsiding in his eyes. Ganpat Rai would accompany his son to Calcutta and there Hardyal would be placed in the care of his friends, who were taking the same steamer to England.

'You'll like Colombo,' Wall had told him, encouragingly. 'The Galle Face, where a brown sea rolls up the beach . . . and where you pass the Island of Socota think of the pirates who still prey on coastal shipping. You'll go up the Red Sea into Suez and you'll look at the Mediterranean, and the Straits of Messina with the land olive-green in the early morning and Naples . . .'

Homesickness had made Aubrey Wall poetic. But to Hardyal everything seemed far away. The tennis party of a few days ago might have happened last year. An age had rolled over him, he felt stranded on a reef of loneliness . . .

Hardyal did not look back as the carriage rolled past the tennis court, between the gardenia hedges, past the women's arbour where all was silent, through the gates, past the poppy-fields and the bazaar to the station. Now he stared past the end of the train to a tossing grey-green of trees. Beyond them lay Amritpore and everything he knew and had ever known, but already it had passed out of his reach, already it was immersed in itself, excluding them.

Re-reading *Indigo* I think of my friend Vikram Seth, who wasn't born when I came to Thorpeness. Maybe he would scorn it. When he came to see me in Suffolk I showed him the great elm at Nayland which had

escaped the plague and still rose to the skies. He brought me a birthday cake about six inches across.

Before setting out for Thorpeness I had written a little essay on George Crabbe. Naturally, one might say. Who else? One of my first walks was to where I thought his leech pond might be. How frequently as the boy-doctor of Aldeburgh he must have walked to it to fetch leeches for blood-lettings. But also to surreptitiously collect herbs for cures, because his patients found them laughable if not a cheat. Medicine! What next? Later he would describe this world, this flight from the coast to become a writer, to his son, beginning, 'One happy morning . . .'. But he was not a Laurie Lee. In 1780, when he was twenty-six, and after 'starving as an apothecary in a little venal borough in Aldeburgh Suffolk', as he put it in a begging letter to Lord Shelburne, Crabbe fled to London, there to starve in earnest.

The Gordon Riots are in progress and sights far worse than he had seen before surround him the minute he leaves his lodgings. He is in tatters and he is ashamed. Anxiety consumes him. In an age of patronage no one will patronise him. To understand his despair one has to recall all the humiliations, his blacking-factory fate, which have pursued him since boyhood. He is a great writer but not an accommodating one. Finally he writes to Edmund Burke, who amazingly takes him into his house, listens to him, and reads him. All this after

standing by the leech pond whose soggy patch I think I pass most weeks. Crabbe's son said,

> He went into Mr Burke's room, a poor young adventurer, spurned by the opulent and rejected by the publishers, his last shilling gone, and all but his last hope with it; he came out virtually secure of almost all the good fortune that, by successive steps, afterwards fell to his lot . . .

That's the way! What inspired him was the Aldeburgh Parish Register. It would be the Borough's downfall, and Benjamin Britten's inspiration.

The poet Neil Powell, describing the leech pond's later views of the holiday village of Thorpeness and Sizewell nuclear power station, said that if George Crabbe thought that the bleakness came from within himself, 'he could not have chosen a better spot to complement it'. He remains our most uncomfortable poet even today; parson, doctor, botanist, and social historian rolled into one, Crabbe is amazing. But he never revoked the Aldeburgh sea and would ride miles just to stand and stare at it. No other sea would do. Maggi Hambling goes to stare at it every day.

Thorpeness was a fishing hamlet with a harbour which had suffered metamorphosis in 1912 and become everything that a colonialist on furlough could need. My bungalow had preceded it by some thirty years and

was like a Raj dwelling which had been airlifted from the Hills to within feet of the North Sea like an Indian version of Holy House at Loretto. Lloyd-loom chairs, card tables, chintz, bright rugs, ashtrays. Benares brass. And threading through its chinks the everlasting timpani of stones, millions of them in endless movement, raking, clattering softly, wearing each other into spheres, which I found quite wonderful and missed terribly when I left. This shingle spit petered out just below me.

My landlord, Captain Foljambe, had bought the bungalow for his sons. But one had drowned in a yachting accident and the other never came. They were my age. The drowned boy was Christopher. I sent his father thirty shillings a week for what I often felt was an intrusion. I must leave in May – 'In case we want it.' May was light years from January. The lovers in my novel and 1939 itself could travel far by then. I wrote a short story about India which benefited from my not having been there and sent it to the Italian magazine *Botteghe Oscure* and also a story about a woman going crazy over shingle and sent it to John Lehmann. It was my walks to the post office which told me the strange tale of Thorpeness itself which was in its way a work of art, or hope, an Empire holiday camp for the stranded middle class, some of them hard at work where the sun never sets. Like St Petersburg, it was built on a marsh. It was the accomplishment of two Scots, a barrister named Glencairn Stuart Ogilvie and his inspirer – J. M.

Barrie. The war had taken the shine off it when I was there. It had become a shabby film set for interwar dramas and the big cast of owners and servants looked as though they would never come back. Memsahibs, governesses, chauffeurs, amahs, gardeners, housemaids, all the children – Anglo-Indian boys like Hardyal – were no more. I was the only light drinker in the Dolphin, where the cover of Stuart Ogilvie's play *The Meadows of Makebelieve* hung on the wall. A water tank disguised as the House in the Clouds needed a coat of paint. Everywhere I looked I saw the ghosts of Thirties golf, tennis, dances, picnics, gramophones, children splashing about, peeling walls and wild rockeries, lawns, tall climbers. Although here and there someone would be up a ladder and would call out, 'Lovely day!' An old woman from the pre-Ogilvie age did my washing for five shillings a fortnight, returning it wrapped up in the *News of the World.* It was a black clapboarded place piped with white which was at that moment pulling itself together for its third manifestation. Did James Barrie see it at its birth? I fancy not. Between the wars it offered some shelter from the storm and as I explored it in 1955 it spoke less of *Peter Pan* and *Treasure Island* and more of E. M. Delafield's *Provincial Lady* and Richmal Crompton's *Just William.* I saw that my characters must have nothing to do with it. They would have to live somewhere less reassuring – Aldeburgh of course.

This first night of my freelance days I went to bed very much awake. I unrolled a damp mattress, found some sheets, put on a fisherman's jersey over my pyjamas – Christopher's? – and felt strangely undisturbed. Outside the North Sea was roughing it up. I imagined Benjamin Britten as a little boy in bed above his father's dental surgery on the front at Lowestoft listening to it day in, night out. The sash windows rattled. It wasn't light until eight, when a snowy haze entered the room. I ran across the dunes, the thinning stones, the thickening sand to the water's edge. And there it was, a sea standing like a wall with a trawler on a knife edge. Mornings are transformations. Britten once told me about them at Snape Mill. How he would leave a shiny black piano downstairs and find a matt white one when he woke up. Old, old flour would drift down on it from the seamy beams all night. I thought of it cancelling the black notes; and of his long knotted fingers finding them out.

Exploring the world of Seaside Bungalows Ltd, the enterprise which had transformed Thorpe into Thorpeness, I was more interested in the shore which had made my friend Denis Garrett a plant pathologist than in its Edwardian pleasures. He was one of the many Garretts who appeared to have fled from the family firms at Leiston and Snape to pursue his own path. We had met a few years before I became a writer, he and his wife Jane, her sister Juliet, the poet James Turner and, soon,

there would be a little band of us finding our feet in a post-war universe by the North Sea. Also for me John Nash and his wife Christine Kühlenthal – my muse and the discoverer of the bungalow with the glass room on the shore. I imagined Denis as a lad passing by, eyes down, entirely absorbed as he would always be, utterly enthralled by plants whose only other plentiful habitation was on Chesil Bank in Dorset. Chesil from *cisel*, Old English for shingle. That summer I would see them myself for the first time, Denis showing them to me as we walked to the Martello Tower. Most famously the sea-pea and the sea-holly, both edible, the first when one was starving, the second when one was sampling the local haute cuisine. I asked John Nash to make drawings of them for the ninth Aldeburgh Festival Programme Book.

The sea-pea, *Lathyrus maritimus*, was famine food; sea-holly, *Eryngium maritimum*, delicious food when sexual appetite was at a low ebb. It was candied at Colchester, the centre of the eringoe trade, and was on the menu for centuries.

MISTRESS FORD Sir John! Art thou there, my deer, my male deer?

FALSTAFF My doe with the black scut! Let the sky rain potatoes; let it thunder to the tune of Green Sleeves, hail kissing-comfits and snow eringoes . . .

According to Geoffrey Grigson sea-holly roots grope through sand and shingle five or six feet, and have waxed leaves which reduce their respiration. Both plants – and a small apple tree – flower near Maggi Hambling's memorial to Britten on the beach north of Aldeburgh. It takes time to realise how floral shingle is, how pale blue and pale grey, how burgeoning – and how local. Denis's father Frank Garrett may have thought of it, and not poppies, on the Western Front. My father would have been at Gallipoli that year, another Suffolk boy out of his terrain. At Cambridge there would be a special Chair for Denis, to acknowledge his wonderfully practical botany – the diseases of corn and rice. Whether this grew out of his knowledge of the edible plants of his childhood which flourished between Thorpeness and Orford, I doubt. I never thought to ask him. His ashes dust Wicken Fen in Cambridgeshire where on our walks he would be received like a prophet.

The Garretts *were* Aldeburgh. In the nineteenth century the family had built the Snape Maltings and the Leiston Ironworks. Newson Garrett's daughters – Elizabeth Garrett Anderson ('cousin Lizzy') and Millicent Fawcett ('cousin Millie') – would go on to change the world for women. Elizabeth Garrett Anderson was the first woman doctor and first woman mayor; her sister would become Dame Millicent Fawcett who frightened the politicians as a formidable advocate of women's suffrage as well as helping to found Newnham

College. We would listen to Denis's wry family anec-
dotes. My favourite was when the widowed Dr Garrett
Anderson moved from cold Alde House to a cosy flat in
the stable, to the consternation of Aldeburgh. A depu-
tation of aldermen visited her to persuade her to return
to the great house and to her position in local society.
Her fury was terrifying when the penny dropped. 'Have
you forgotten that your Maker was *born* in a stable?'
And there she stayed. When Denis and his wife and
daughters came to Aldeburgh in the summer there was
no mention of the Festival. They were neither for it nor
against it. 'Their Aldeburgh' failed to contain it, being
so full of other things. Such as tramping head down for
miles and miles to renew contact with minute friends
on the marsh or on the beach, to get healthily blown
about, to feed me in pubs, but chiefly to take in their
native air, the air of George Crabbe's Borough:

 The bounding marsh-bank and the blighted tree;
 The water only, when the tides were high,
 When low, the mud half cover'd and half dry;
 The sunburnt tar that blisters on the planks,
 The heaps of entangled weeds that slowly float,
 As the tide rolls by the impeded boat.

After church on Sundays I would study the lichen on
Church tower and on the drowned sailors' tombs, as
Crabbe had done, as he wrote what must be the finest

botanical poem on the subject. The churchyard was huge and blowy. The vicar was Rupert Godfrey, a pale, still young man who had been in a Japanese prison camp, an ascetic who was uncomfortable with the Festival. He was on its Council and once caused sophisticated amusement when Britten's opera *The Rape of Lucretia* was proposed for the 1954 Festival: 'Can't we have less rape?' When I was told this I thought that maybe he would have been the only person present who could have seen rape. The war had lapped over us all, one way or another, leaving its sediment. I became fond of Rupert and his wife and wrote a new church guide for him, and got John Nash and Kurt Hutton to illustrate it. It sold for decades. Rupert worried about the behaviour of Festival audiences in church. He had a puritan streak which, like his face, contained a chilly beauty. It was unusual in the Fifties for parish churches to be commandeered for music festivals and sometimes I sensed that he would sooner not have had this. 'Aldeburgh' invaded his austerity, but, like the sea, he could do nothing about it. I think that the first church concerts had to be without applause. When a concert these days is clapped to a near-insane degree I think of Rupert. Crabbe had a bad time when he returned to Aldeburgh as curate. But he got his own back – and how! His bust stares up at John Piper's Britten memorial window, stony-eyed. The window flames.

It was the exterior of Aldeburgh Church which spoke to Crabbe of immortality – those furry mosses, those botanically cancelled names:

> The living stains which Nature's hand alone,
> Profuse of life, pours forth upon the stone.

I would walk through Crabbe's churchyard reading names to Godfrey. Once I began explaining that the Ropes were Rationalists and he said coldly, 'Never mind the Rationalists.' But in Aldeburgh one had to mind them. Its climate and bitter history had made them a force to be reckoned with. Under our feet were the rough worshippers, the sea-killed men and boys, the real Ellen Orford, a woman who could not forget, the shore gentry, the medieval mind itself – and 'seeds to our eyes invisible'.

But this is running ahead. It is January and thin snow falls unceasingly. The church tower, the small town, are smudges. The birds alone are distinct.

2 Morgan

A week or so after settling into Fairhaven I walked into Aldeburgh to buy food. It was still snowing but in a faint, whirling way which hid the sea and the marsh. Coming from the opposite direction, blinded like me, an elderly man was stepping it out. It was E. M. Forster, a recognisable figure even if I had never seen him before: we passed each other silently, packed snow deadening our footsteps. He walked quickly, lightly, even youthfully one might say. He wore a tweed overcoat and a flat cap. Returning about two hours later I found a page from a pocketbook thrust under the door – there was no letter-box. It read:

4 Crabbe Street,
Saturday
Dear Mr Blythe,
 If you are free today and can come in for a drink,
we shall be very pleased to see you.
 Yours sincerely,
 E. M. Forster

Bewildered, troubled by this – its unlikelihood – I went of course. Four Crabbe Street was Benjamin Britten's

house. Forster let me in, shook my duffel coat before hanging it up, showed me into a room where every surface, including the piano, was littered with paper slips, and said, 'Sebastian Sprott.' They were indexing *Marianne Thornton*, the 'domestic biography' of the aunt whose money had given Forster financial freedom. They were gentle and charming. Indexing being part of my trade as a librarian, I made short work of that for her biography.

As we gathered up the slips Forster said, 'We eat at lunchtime', and fetched sherry and biscuits. And of course, 'What are you reading, Mr Blythe?' I should have replied *Indigo*, or Camus, but for some reason I answered, 'Elizabeth Bowen', causing their eyes to meet. It made me defend her, at which they too praised her. I felt shy and vulnerable, immensely hungry, and unable to explain myself. I wondered how and when to leave. At about nine Forster helped me on with my coat and said that they couldn't thank me enough for my assistance. Starving and cold, I went to the White Lion Hotel and sat by a great fire, feeling that I had failed some kind of test. But shopping in Aldeburgh the following week, Forster hurried from Britten's house to greet me. He hoped that I was looking after myself. He carried my straw fish-basket. He bought Quink in the bookshop. He hoped – felt sure – that I would not always be alone. His voice was disconcertingly youthful, his features rather foxy, although with fine eyes behind

the glasses. And now we talked easily about literature and about ourselves. Thorpeness was indeed odd, though 'most interesting'. It was the moment to ask, 'How could you know I was there – a totally unknown young man hoping to become a writer?' But some rule which I couldn't understand stopped me from saying it. I wrote in my diary, 'It has begun.' 'Now the fishmonger's, did you say, Ronald?' Now the baker's on the corner. Now the observing glance.

Britten and Forster were old friends when I met them in 1955. Forster's BBC talk on Crabbe, printed in the *Listener* in 1941 and read by Britten and Peter Pears in California, had famously returned them to their rightful element. Morgan, as I was soon awkwardly to call him, had been present at the first night of *Peter Grimes* a decade earlier, when he was stunned by the glory of the music but shocked by the liberties taken with George Crabbe's devastating poem *The Borough*. 'Well might you warn me that the libretto departed from Crabbe,' he wrote to Eddy Sackville-West. 'I thought it did so disastrously, and it was so insistent both as narrative and psychology that it imperilled the opera, especially at the end.' Bit by bit I would learn that Forster's understanding of Crabbe, still a little-read genius, was profound. So what was it that upset him in *Peter Grimes*? It was that Ellen Orford and Peter Grimes, who had no contact at all with each other in *The Borough*, had become old friends in the opera, Ellen schoolmarmishly

respectable, Peter helplessly the local bad lot. Crabbe could not be so elementary, so crass.

The Borough is a series of 'Letters' from Aldeburgh. Candour is their watchword. Ellen Orford makes her appearance in the twentieth Letter, Peter Grimes in the twenty-second Letter. Ellen is now an old blind widow who has been a schoolteacher but also a Hardy-like plaything of fate. A less-like Ellen of the opera could not be imagined. Her husband was a violent brute, one of her sons was hanged, another drowned. Awfulness follows awfulness in lengthy statements. Her role in the poem is of a stoic, someone whose 'senses fail not at all' and who at last comes to 'my winter calm of life'. Crabbe could have been reading The Book of Job. Ellen Orford's Letter is so terrible that the reader can barely continue. Peter Grimes's Letter shows insanity as a mercy; Ellen's sanity as a torment. *The Borough* is a masterpiece, as is the music of *Peter Grimes.* Somewhere in between the librettist Montagu Slater has taken his liberties with a shocking text.

The young Benjamin Britten put what could not be said into music and orchestrated Aldeburgh's sea and climate itself. He also found in George Crabbe's pity for the victims of child labour, a commonplace in his time, a text for that 'pity' for boyhood which would so compulsively run flame-like through Britten's work, and throughout his life. Forster of course, having been shown the ruthless convention of the librettist in *Peter*

Grimes, had dealt with *Billy Budd*, and with huge respect for Herman Melville.

That autumn I found the second edition of Forster's *Alexandria: A History and Guide* in the second-hand bookrack near the newsagent's – 'by E. M. Forster M.A. Cantab, L.L.D. Aberdeen' and published in Alexandria in 1938. 'To any vision must be brought an eye adapted to what is to be seen' – Plotinus. Now it remains my conviction that this work is not less than the novels as a compendium of Forster's thinking and beliefs. I intended to get him to sign it when he next came to Aldeburgh but something told me that it would be a mistake. It had lemon-coloured hardboard covers, many maps and designs, photographs, and 218 pages. I treasure it still. Unbeknown to me at this time Forster would lecture on it at the next Festival, the one for which I would edit the Programme Book in 1956.

Its second importance for me was that it introduced me to Constantine Cavafy – the poet who stood at a slight angle to the universe when Forster lived in Alexandria. No guide to Alexandria could leave out Cavafy. So Forster included what would be my first encounter with him. 'Ithaca' I would of course have to find for myself. Forster placed Cavafy's poem between his history of Alexandria and the guide to his own exploration of it. Cavafy had died in 1933 and his presence haunts the second edition of Forster's book.

The Alexandria I knew and loved belongs to the
war years. I was very happy there, in the intervals
of my work, and gradually fell in love with many of
her inhabitants and the whole of her past. She was
then a tousled unsmartened sort of place . . . Hadra
was still a lake, Marabout a desert island, Montazah
a convalescents' paradise . . . it was permissible to
bathe in the Friars' Pool without wearing any
costume. All this has vanished with the advent of
modernity and the Corniche Road, and few except
myself will regret it. I realised what was coming
a few years back, when I paid a brief visit and lost
my way as I came out of the new railway station.
What a humiliating experience for the author of
the Guide . . . I desire to thank certain friends
who are no longer alive. They belonged to many
nationalities.

They included his first lovers. He was in his late thirties
and Alexandria had conquered Weybridge. He dedi-
cated 'this volume to one of them, to C. P. Cavafy,
Greek by birth, Alexandrian in spirit, and a great poet.
Abingdon, England.' So here is my first knowledge of
Cavafy, as chosen by E. M. Forster. I read it sitting on
Aldeburgh beach.

THE GOD ABANDONS ANTONY

When at the hour of midnight
an invisible choir is suddenly heard passing
with exquisite music, with voices –
Do not lament your fortune that at last subsides,
your life's work that has failed, your schemes that
 have proved illusions.
But like a man prepared, like a brave man,
bid farewell to her, to Alexandria who is departing.
Above all, do not delude yourself, do not say that it
 is a dream,
that your ear was mistaken.
Do not condescend to such empty hopes.
Like a man for long prepared, like a brave man,
like the man who was worthy of such a city,
go to the window firmly,
and listen with emotion
but not with the prayers and complaints of the
 coward
(Ah! supreme rapture!)
listen to the notes, to the exquisite instruments
 of the mystic choir,
and bid farewell to her, to Alexandria whom you
 are losing.

Forster was a spellbinding lecturer, the 'old Cambridge' accent, if it can be called that, the witty sadness, the glinting glasses, the admitting of his hearers into the Forsterian country.

Sitting in the Jubilee Hall on a Sunday afternoon, thanks to the clumsy volume in my bag I saw young Morgan approaching the Rue Lepsius and Cavafy waiting for him in his grandly furnished and poverty-stricken house, and then not finding this address, that association.

> I never found them again – so quickly lost
> Those poetical eyes, that face
> Pale . . . in the darkening of the street.

It would have been years after I left Aldeburgh that I discovered Cavafy's 'Ithaca', years after Morgan and I walked to the Martello. My novel *A Treasonable Growth* was published a decade before his death in 1970. In it my Forsterian lovers watch from the Town Steps:

> There was a bench at the top of the Steps. Richard flopped down and stared at the glittering sea. The Town Steps, forty or fifty of them, swept away in a torrent of shallow treads . . . the sea seemed to be both below and above him . . . Coasters looking sacred in their anchored stillness balanced perilously on the horizon, their illuminations, larger,

lower stars. He could just make out the danger
signs. The Greek letter held high over the deep had
a curious bitterness. As well as warning, there was
something kill-joy in its angularity. It should have
been a good place in which to think . . . But he
couldn't think. He could only remember.

3 Travelling with Julian

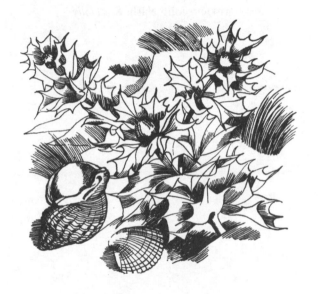

As a teenager I was captivated by Julian Tennyson's *Suffolk Scene*. It accompanied me on countless bike rides. I knew it by heart. Much later his brother Hallam became a close friend and I met their father Sir Charles Tennyson who was almost a hundred years old, an elegant ancient man who used to live in Aldeburgh, then in Peasenhall. Julian had written about the Martello Tower and with this robust chapter in mind I followed him to it. He had written *Suffolk Scene* on foot and on his bike. So at Thorpeness I read him yet again. He had asked for comparatively little in life, just to edit a sporting magazine when the war was over. All he begged was the freedom of a bird. Sir Charles sent me the family photograph album and told me as much about him as anyone could, his brother Hallam included. In 1939 he joined up, carrying with him books by George Borrow, Richard Jefferies, and Robert Nichols. Also the first page of *In Memoriam* in manuscript. His father said, 'Oh, if only you could have seen the English countryside before cars!'

Julian had seen the Aldeburgh marshes and the coastal sandlings at the end of their popular reputation for wretchedness, superstition and crime. And before the

repair of their complex network of ancient dykes and sea walls. Not that either was much good. Generations of marshmen had toiled futilely against the sea's merciless encroachments, tiny Sisyphuses or grown-up children turning out mud castles which could only be washed away. Julian had lifted his eyes. From his day on the Suffolk marshes and sandlings, that ten-mile border which stretches between the arable soil and the shore would acquire its present status of a wild-life haven. He wrote,

When I lived in Aldeburgh I used to lie awake at night listening to the curlews flying over the town. They seemed to have a route which passed directly over our house. Often as many as six flocks would come over together, heading northwards, and when their last calls had died away on the thin air, I would gradually doze off in the long and even silence. 'Cur-leek-leek, curr-leek-leek, cu-r-r-r-r-leek' – they were coming south this time and, drowsy as I was, that shrill bubbling whistle would sent me rushing to the window to peer among the stars and catch the vague shapes as they swept over the hill and down towards the marshes. Then I would fall asleep wondering whether these were the same birds that passed and re-passed along that aerial road in the night, or whether by mutual agreement they were carrying on a system of exchange in the marshes up and down the coast.

Curlews are shy and mysterious, and I found
them the most restless birds on the river. Even in
winter they were always on the move, as if they
couldn't be satisfied with the same place for very
long, and must be up and away looking for some-
thing new. Night after night they went, wailing
their frustrations; but in April, when they left for
their breeding ground and the flocks came over
all night long, there was a purposeful, almost
triumphant feeling in those sharp voices. The
notes were quicker and higher, and sometimes they
lacked the hesitant, purring quaver altogether.

I never realised my ambition of taking a census
of the spring passage of the curlews . . . When I
went to live inland I found that what I missed most
of all was the calling of sea and marsh birds in
the night. There is something sad and strange and
lonely in the sudden, piercing voice that comes out
of the darkness above you, the voice of a bird
travelling at sixty miles an hour . . .

My practice was to work on my novel in the morning
and to explore the coast in the early afternoon. This
was short and I often walked home in the dark. I bor-
rowed local books from the Aldeburgh Public Library
where Miss Redstone advised me. She introduced me to
Miss Howe, whose mother had been housekeeper to
Edward FitzGerald. Miss Howe showed me his shawl

and his inkpot. I had entered a world of wanderers and coastal seamen, people who made an uncertain way in life. As the days lengthened so did my mileage. Orford and Kessingland needed early starts. Then there came the dramatic hold-up at Slaughden, just south of Alde-burgh, of the Martello Tower, the last of them to be built.

Something about the Suffolk coast made it an open invitation to an invader, first Napoleon, then Hitler it was thought. It was Captain William Ford who sug-gested that we should copy a circular tower he had seen the Royal Navy bombard – but to no effect – at Martello Point in Corsica in 1794. One hundred and three Martello Towers were built, all made of brick, the largest and northernmost in Suffolk, at Aldeburgh. This was a vast quatrefoil sloping shape standing in a brick saucer, its walls eight feet thick and thirty-three feet high. It was the ultimate expression of the sandcastle turned out of a tin pail into a sand moat. Tastelessly, considering its sad history, a jazz-age eyrie had been constructed on its roof. Yacht Club lanyards rattled in the wind below it and there was a rearing tarred Peggotty-boat with white windows near by. George Crabbe's humiliation at Slaughden, his tough experience heaving the salt barrels about, took place long before the Martello Tower existed. They said it was stuffed with French prisoners after Waterloo, neglected, for-gotten creatures. It was their cries I heard, not the poet's resentment. I thought I heard them singing, 'Do not

weep for me, Lisette, let not grief your beauty stain.' I saw them carving fishbones and writing graffiti on the bricks, and being thrown grub like animals. Later on this year I would climb into it, and be shocked by its brick power. Julian Tennyson regarded it cheerfully. 'Had Napoleon landed . . . it would have been Corsican against Corsican.' He too had climbed in and surprised a courting couple with his wicked shrieks. It was a Sunday afternoon.

A Martello Tower is beyond being war litter like redundant anti-tank scaffolding, minefields and barbed wire. Most of this had gone without trace in 1955. But not the signature of the great 1953 flood, which was still writ large wherever I went. It was sordid, a mark of wretchedness, a reminder of what the North Sea could do if it chose. There having been a two-centuries gap since it behaved so nastily, the general feeling from Canvey to the Wash was that it would not do anything like it again for ages. But serious defences were being built. Those built by the Catchment Board from the White Lion to the Brudenell Hotel by the end of 1949 proved useless on the night of 31 January–1 February 1953. The sea rose over them and filled the town at will. It wanted to show that it could do what it liked. Yet near as they were these dramas of the coast became a past history to me as the present enormity of being 'a writer' itself became a kind of flooding claim, needing to obliterate everything that had gone before. Far from

this being a self-certainty, I could only mention it to my friend James Turner, since I was in full imitation of what he had done many years before. He watched me anxiously, spoke a lot about money and did not approve of 'Aldeburgh'.

But Denis Garrett did, although never in Festival terms. By coming to Aldeburgh I had entered Denis's 'holy ground'. In the summer of 1955 he showed it to me as he plant-hunted on the shingle. Bending from the hip without bending the knees, he would look closely and adoringly at sea-holly, sea-pea and all the other shingle plants, tenderly regarding them like a returning prodigal.

Our first impressions of a town are likely to remain to some extent. Mine of Aldeburgh in the winter of 1955 have stayed indelible although a great many later sights of it have extended or balanced these. After the shore I trod the borough. The High Street must have had herds then carriages in mind – like Long Melford and Hadleigh. Newson Garrett and Victorian cold-climate enthusiasts had put a halt to Georgian decay with flashing plate-glass windows and massive gables. Whilst flood-boards remained propped along the Crag Path, balconies were being strengthened. The light was brilliant. It poured in from all corners of the sky. There were 'marine residences' on the high ground and strong terraces broken here and there by ancient cottages which Crabbe would have known. The Moot Hall, once

in the centre, stood like a beautiful Tudor toy almost on the beach. Like Thorpeness, there was evidence of the fantasy life of the Edwardians, a love of sundials, a play of decorative stones. Almost everything that had been built since, maybe since the 1820s, had been confidently and handsomely created, although a Garrett mercantile insistence touched every brick. However, there remained a hard speculative element in the recent architecture. But it was not 'sea-side-y'. Neither was it charming like Southwold. Or resortish like almost every other coastal place. There was something powerful about it which was not easy to fathom and which made the decision to found a festival of music and the arts there so soon after the rough ways of the Second World War either fool-hardy or challenging. And yet I don't believe that either of these hazards so much as entered the heads of Eric Crozier (the suggester) or Benjamin Britten and Peter Pears. The more likely reason was the useful Jubilee Hall, which Skelton Anderson, Elizabeth's husband, had built to celebrate Victoria's sixty years on the throne. He also created the golf course and might now be seen as a kind of rural Albert to his wife's reign over the borough.

Alde House, where Elizabeth Garrett Anderson had lived, had been divided into flats when I was there. Norah, the widow of the poet Robert Nichols, lived in one of them and she lent me books. Here and there all over Aldeburgh there was this cultured residue of a

previous age, some of it going back to the visits of Thomas Hardy and George Meredith, and, in Miss Howe's case, to Edward FitzGerald. Past and present concertinaed. From feeling stranded I began to feel that I was in great company, although staying solitary all the same. I expect I must have poured these confused thoughts out to Norah Nichols, as I had done to Christine Nash, whose common sense had landed me on the shingle beach. Christine would drive over from Wormingford to see how I was getting on, sometimes staying the night, when we would get up a good blaze of driftwood. Once in early May she thought it would be warm enough to have a swim. I watched her, a tall woman in her late sixties wearing an optimistic straw hat and smoking a cigarette in an amber holder, splashing up and down. 'Oh, do come in, my dear!' Life, our multitudinous scraps of it, was a kind of pointillism which we tried to fix into shape. The ultimate joined-up writing. I veered between Tennysonian (Julian) cheerfulness and Hardy-like morbidity and once searched for the little building 'for washed-up bodies' in the churchyard.

At Snape I had seen the gradual emptying of what was almost a malt city. One by one its workers fled. They had once walked or bicycled there in droves; some, after harvest, from as far away as West Suffolk to earn 'Christmas money', sleep in sheds and supplement their wages. Newson Garrett's great enterprise on the site

had lasted a century. Denis and Jane Garrett and I once went there to stare on that Victorian desolation. A malt barge rocked by the hard. Denis of course was looking at those plants which so soon come to occupy an abandoned site. The marshes were alive with birds. Iken glistened distantly. There seemed to be countless brick buildings all cobwebby, all deserted. We stood under the clock. Like all Victorian entrepreneurs, Newson Garrett worshipped time. The clock was going. We would watch a malthouse become a concert hall. To their horror, Newson and his wife would watch their daughter Elizabeth become a doctor. 'The whole idea is so disgusting I could not entertain it for a moment!' declared the father. 'Oh, the disgrace!' cried her mother. Snape Maltings at that moment was like 'Nineveh that great city' – teeming with workers. Now it was a desolation. But at the same time a starting point for the three of us; Denis would go on to his Cambridge Chair, Jane to become a distinguished social worker in Cambridge, and myself to writing.

Although at this particular moment at Snape Maltings there were no plans, no sense at all of a common future – only a kind of mutuality, and a comfortableness with each other. And I suppose a taken-for-granted recognition of our always being together in some indefinable fashion. Whether our being deeply rooted in East Anglia in our various ways had anything to do with it, it is impossible to say. I suppose we just 'fitted'.

There was no analysis, just an accepted continuum. Standing under the Maltings arch after there were no more workers left to clock-in timed our future.

4 How I Came to Wormingford

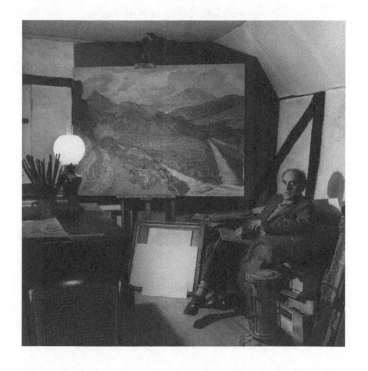

CAPTION: John Nash at Bottengoms

The time by the sea was also in part the first time deeply inland at Bottengoms, the home of John and Christine Nash, in the village of Wormingford, eight miles north of Colchester. Not unlike Imogen Holst's dutiful flights to Thaxted in some ways; she to her mother, myself to giving a hand.

John Nash first came to Wormingford in June 1929. It was a wet, cold month 'and I began to tell myself, this is no place at all . . .' His wife Christine, always less easily depressed, sent a Judge's postcard of the Mill to her mother with the message, 'Good river scenery. Think we may stay here.' Christine had discovered this particular working-holiday cottage through an advertisement in a local paper, and after a fruitless search around Framlingham for a suitable spot where John could paint. Throughout her married life, making such reconnaissances, often two or three each year, 'were part of my job', she said. 'I don't wish to boast, but it was only the places which I did not go to look at first that weren't successful.' During the early years of their marriage she had vetted these painting locations by bicycle, pedalling for long distances all over southern England,

and along the Gower peninsula, to find landscapes for
John's sketchbooks. These he would fill with pencil and
wash drawings, complete with weather and colour
notes, to be transcribed on to canvas during the autumn
and winter. Like most young artists, they roughed it in
their first attempts to make a living. Christine made no
bones about it. 'We very often had some awful places to
stay. We were hard up, and really we had to endure a
great deal, but we did have to have the right kind of
scenery!'

They arrived at Wormingford Mill in fine style,
however, due to the legacy of a sturdy 8.18 h.p. Talbot
motor car which the previous owner, their dear friend
Francis Unwin, used to drive round Brooklands. Unwin,
one of the finest etchers of his time, had died from
tuberculosis in Mundesley Sanatorium in Norfolk in
1925, and it was partly from a number of sad visits to
him that John Nash had become attracted to East
Anglia. His roots were in the Chilterns but family con-
nections near Colchester had made him familiar with
the Suffolk–Essex border. Paul Nash had actually taken
part in the epic 1909 Colchester Pageant, and both
myself and John were to wear his Tudor costume on
fancy-dress occasions half a century later. But Worm-
ingford in 1929 was entirely new to John and Christine,
and when the sun came out by the flower-choked river,
the village's potential as a working-holiday location was
evident. Some might say, 'No wonder, with Gains-

borough painting almost up to it and Constable almost down from it!' But these celebrated associations meant curiously little to John. He himself was to become famous for what appeared to be an indifference to any art other than his own, and this not because of pride, but because of the way in which he was so entirely dominated by his own vision of landscape. Sickert used to warn artists off the Stour Valley, saying it was a 'sucked orange', but John Nash painted it as though he had never heard of it being the most familiar river territory in English art.

The holiday house turned out to be a little clapboard bungalow adjacent to the Mill with a rustic fence and a view of the race. Box Brownie camera snapshots show an easel set up on the bridge, a punt containing a picnic and a portable gramophone, and John poling it through the reedy water, dressed in pyjama trousers and a jersey; Christine bathing and fellow artists sketching. The unpropitious June of 1929 had turned hot, and the long association with Wormingford had begun. He was thirty-six and had been an artist for seventeen years. In this comparatively short time he had taught himself to paint, to be a first-rate botanist and a good musician. He had achieved considerable recognition with his first show, had fought on the Western Front with the Artists' Rifles, had as an official War Artist painted two of the greatest pictures of the fighting, had married a half-German, half-Scots Slade student named Christine

Kühlenthal, and was at this moment one of the leaders of the renaissance of book illustration which had taken place during the 1920s. He was a slight young man with large aquiline features and reddish-brown hair. His wife Christine was tall and dark. She no longer painted – 'One artist in the house is enough' – but was at this time active in Cecil Sharp's English Folk Dance and Song Society, and her interest in movement and drama would, years later, be fulfilled in the many plays which she produced or acted in at Wormingford. Her 'dancing' step – like Imogen Holst's, a leggy kind of gracefulness – remained with her until old age – and I always loved the way in which she would take off for a long walk with never a thought about the distance or the weather. Once the two of us walked from Bottengoms to Stoke-by-Nayland in thin rain, and we regularly walked those perfect footpaths which meandered from the house to Sandy Hill, via the Grange, the mere and the high ground past the church. John used to call all this countryside 'the Suffolk–Essex Highlands' and he liked to surprise guests by taking them off to see such untypical East Anglian contours, but always by car, never on foot.

John and Paul Nash, and their sister Barbara, were the children of a Buckinghamshire lawyer, William Nash, who became the Recorder of Abingdon. All three were inspired by the Chilterns' beechwoods and chalky escarpments, and by such strange phenomena as the

ancient tumuli known as Wittenham Clumps. They lived at Iver Heath, then the deepest countryside during those pre-First World War days. One of their aunts had been engaged to Edward Lear and it was at her house that John first became influenced by comic drawings, as well as by Lear's pale and exquisite watercolours of his travels. Both Paul and John were 'pointed' to painting by literature, this and their profound understanding of both the mystery and the practical lie of the land. It was John's first intention to become a writer, and he apprenticed himself as a teenager to a local newspaper, learning shorthand and trying to learn style. But in 1912 a friend of Paul's, the artist Claughton Pellew, took him off on a walking tour in Norfolk, talked to him, showed him what he was really seeing, which was line and colour, not words and plots, and sent him home to Iver determined now to paint, not write. His father, hearing the news, said John, cleared a space on the dining table and said, 'You had better do it here.' Paul was studying at the Slade. Should John go to an art school? 'No,' advised his brother. 'The teaching will destroy the special "thing" which you possess, so teach yourself.' It was daring advice but it proved right. I always remember old Mr Nash's making a space on the table and saying 'Do it here' when John used to make a space for me on his painting table just before setting off on his work-holidays, so that I could write. But writers don't like north-facing studios, so I would find a sunnier

spot, although not confessing to this as I used to think that it would hurt his feelings to have his favourite worktop rejected. Ivy grew in a dense curtain across the studio windows and, when I tugged some of it off to let in light and view, John would murmur, 'Poor ivy.'

John's discovery of Wormingford was partly due to the suggestion of Sir William Montagu-Pollock that he would find much to excite him in East Anglia – hence Christine's search for a painting place near Framlingham. Thus two quite casual invitations to the area were to have far-reaching consequences. Claughton Pellew's made him a painter; Sir William's eventually led him to Bottengoms. Such are the small incidents which define what we are and where we should settle. For the whole of the Thirties the Stour Valley alternated with Cornwall and other places as a working-holiday venue. During John and Christine's second visit in the summer of 1930, the old Mill burned down, and the nice clapboard bungalow with it. John's sister Barbara was staying with them and she told me how they managed to rescue some of his pictures from the flames, though not all. This experience resulted in spasms of acute fire-anxiety later on, when they would beg me never to burn paper or 'run with the lamps', something I would never do, having been brought up with oil lamps. Christine loved their soft yellow light and the heat they generated, and their tongues of flame, so Pentecostal and comforting. She put off having electricity for ages so

that she didn't have to give them up. For me they were glowing reminders of childhood, with their paraffin scented wicks and 'Swan' glass chimneys. Later at Bottengoms there would be Aladdin lamps with mantels and fat, battered parchment shades.

For most of the time between the wars the Nashes were living at Meadle in Buckinghamshire. It was there that John did much of his remarkable wood engraving, where he began to make friends with great gardeners such as Clarence Elliott who owned the Six Hills Nursery at Stevenage, and where he painted a whole series of landscapes whose subtle mixture of agricultural realism and underlying poetry established him as an artist in the classic English tradition of Cotman and Girtin. In November 1935 tragedy broke into this disciplined existence and wrecked it. William, John's and Christine's only child, was killed in a car accident. He was nearly five, a little boy who had become part of their happiness in the water-meadows and lanes in and around Wormingford. Hardly knowing what to do, there was talk, as John put it, of selling the house at Meadle and building another near the river here. The need to recover from this disaster apart, they had begun to put down roots in the Stour Valley. There were new friends such as Adrian Bell the writer and his wife, who lived at Creems Farm at Wissington, and they would be nearer to old friends like the Cranbrooks at Great Glemham. In the event nothing happened; the pattern

re-established itself and the idea of moving was put in some kind of abeyance. 'One day'.

Adrian Bell was some ten years younger than John, a loquacious and idealistic person whose trilogy, *Corduroy*, *Silver Ley* and *The Cherry Tree*, had established him as one of the best rural writers of his day. John rented a cottage called The Thatch near Creems – and near the Fox Inn – and they saw a lot of each other. Once the local boys challenged them to bring a canoe down the Stour from Sudbury to Bures, the state of the river, due to the farming depression, the collapse of barge transport and neglect generally, making it virtually invisible here and there in mid-summer, so dense were the weeds, so overgrown the trees on its banks. Some of the now unwanted barges which John Constable had painted had been scuttled at Ballingdon, and lay just below the surface of the water like vast black motionless fish. John and Adrian *did* sail a canoe all this choked length, though with every imaginable difficulty. Bures bridge was lined with cheering lads as they passed beneath, hot, scratched, exhausted, but triumphant. In 1939 John and Adrian collaborated on a book, *Men and the Fields*, which was a work of homage to the farmers and farmworkers of England, particularly to those who, in those hard-up times, were struggling to hold together the semi-ruined agriculture of the Stour Valley. Both Adrian's books and John's paintings reflect what might be described as a lyrical realism, a deep

knowledge of farming plus a pleasure in the designs which, for many centuries, it had carved across the English landscape. For Adrian it was a peopled countryside; for John, a land of plants and shapes whose human occupation was explained in terms of workaday litter, binders, fencing, shepherds' huts, gravel diggings and carts. There cannot be many villages like Wormingford and Wissington, and their environs, which have been the attention of two such excellent chroniclers.

Adrian Bell wrote in his diary,

August 1935

Picture seeking with John Nash. Found something much to his purpose in Kid's Hole at the back of Green's. The artists, man and wife, staying in Greens are stanced opposite here daily, doing a scene in which the Finch harvest-team figures, have to move every time wagon leaves stack. In a great hurry because last load being put on stack, and he hadn't half finished horses and wagon. John wants to do a picture of the valley from under the elm, but dismayed by my warning him that he may find others sitting about.

Bottengoms, like a number of ancient houses in the neighbourhood, had been empty for some years when John decided to buy it. It was 1943. The house at Meadle had been let, he and Christine were absorbed in

war work, and for the first time in their marriage there was no home base. During the holidays at Wormingford and Wissington they had discovered on their walks and drives many forlorn cottages tumbling away in their jungly gardens; they were a common feature of the depressed countryside then. It was Christine who told me of her first close encounter with Bottengoms:

I knew it for years before we lived here. I used to see it from the track down below when we rented a cottage by the river. But I'd never approached it from the road until 1943, when a friend told us that it might be possible to buy it. The farmer who owned it had had it standing empty for eight years, and he'd come to the conclusion that a few hundred pounds was really more valuable to him than just to see it falling into decay. So I came by Chamber's bus from Colchester and walked down the track, which in those days was a leafy bower with hedges meeting overhead, so one walked through a tunnel of greenery. As I walked, I saw an old man coming up the track with a bag over his shoulder, and a stick. We stopped and said Good Morning, and he said, 'I'm the postman. My name is Death.' That was a very good opening. I went on down past the house which was actually impossible to get near to. The nettles and elders were right up to the top of the ground-floor windows. There was no trace of a

garden, no sign of a path. So I continued down the
track and sat for a long time under a willow tree by
a barn and I thought it was the most beautiful place
I'd ever seen, but absolutely impossible to contem-
plate as a house to live in. The idea of reclaiming
it, and maintaining it even if we could reclaim it,
seemed even more formidable. I must have stayed
there under the willow tree at least an hour before,
very regretfully, I walked back up the leafy track.

In an essay which I wrote later, I tried to envisage
both the possibility and the impossibility of coming to
live in such a place. I said that, although the house had
suffered many of the typical vicissitudes of the long
agricultural depression, having all its old fields and
meadows annexed by a neighbouring farm, and showed
in all sorts of ways how it had come down in the world
from yeoman independence to eventually becoming a
double-dweller for farmworkers, and ultimately to years
of abandonment, it retained its own powerful ability to
see out change in whatever form it happened to be. And
Mr Lewis himself, before Bottengoms defeated him, had
made an effort to hand it on in some kind of good order,
for I discovered the following message written in pencil
on the inside of a 'Tenner' cigarette box: 'Feb 19th 1937
painted outside of this House and Distempered inside.
H. W. Spooner and B. Welford, Nayland and Boxted.'
The box also contained a nail and a hazelnut. But the

collapse and slow vanishing of its pathways, barn, piggery and stackyard were another matter. There is little more daunting than a ruined farm. It is one of the saddest of sights. But John and Christine were far from being daunted. The past and the future of Bottengoms lay lightly on their conscience and imagination. In the middle of a war they could only think of what might be done *now*. When I think of them at this time, I am reminded of the celebrated Suffolk gardener John Tradescant who, in the turmoil of a battlefield, was seen, botanising during the carnage, bending down amid the swords and blood to collect some interesting plants. One of Christine's favourite anecdotes was that whilst she examined the rambling ancient rooms, wondering how on earth she could make them habitable once more, John would be outside examining the soil in great excitement and saying, 'Yes, yes, this would do, this would be perfect for my purpose.' The purpose, of course, was to make the garden of his dreams.

A few months before his death, many years later, he published a little philosophical essay on his concept of gardening. The garden at Wormingford came into being because, as a small boy, John's

knowledge and interest in plants had been stimu-lated by an excellent governess whose services we shared with a neighbour's children. Also, down the road there were five maiden ladies, whose garden

was a delight and where again we came in for instruction of a gentle nature. Each old lady preserved her own childhood plot apart from the main garden, and the somewhat unkempt box-edged borders were full of 'treasures'. At home I thought to take our own garden in hand. It had never been planned and contained few plants except some rosebeds edged with 'Mrs Sinkins' Pinks. Father's full-size croquet lawn dominated every-thing and money was not forthcoming for the purchase of new plants. A lasting memory was a colony of *Campanula rapunculoides*, wisely imprisoned between the morning-room wall and the path, while *Eccremocarpus scaber* ran into a *Gloire de Dijon* near by. I still have this latter combination in my garden today.

John's thankful relief at having escaped death in the First War was expressed in his celebrated painting *The Cornfield*, which is now in the Tate Gallery. His grati-tude for being so eager to pick up the threads of his career after the Second World War found its outlet in transforming the jungle at Bottengoms into a haven for the kind of plants he needed to have around him. Carving this garden out was a tough business. With the assistance of his old friend John Langston and a suc-cession of helpers from the village, the rubbish was cleared, many beds cut – including a large palette-

shaped bed in front of the house – the horse-ponds cleaned out and planted with bamboo, gunnera, flags and huge marsh marigolds – 'bull-buttercups', the old Essex people used to call them – paths created and an orchard made. Shaping a new garden in an ancient spot is the kind of treat which does not come often in a life-time. With the aid of a succession of jobbing gardeners (come to think of it, I can't recall seeing John actually digging) a Nash jungle of old roses, bulbs and flowers of every kind replaced the bramble, elder and nettle jungle, and during high summer with very near the same density. Nightingales sang against the sound of the piano or the push-lawnmower and, in winter, owls hooted from the collapsing barn and sheds.

John's plants were made to work for their living, as specimens for the books he illustrated, or as models for his students at the Royal College of Art and Colchester Art School. His favourite flower-painting courses were those held at Flatford:

For many years I conducted a course on Plant Illustration at the Flatford Mill Field Studies Centre. This started chiefly with the ideal of draw-ing the British Flora, but a visit to a local garden full of rare bulbs and herbaceous *exotica* led to defections from the original purpose. [This 'local' garden was that of Sir Cedric Morris at Hadleigh.] There was no wish to spurn the humble forms of

our native flora, but they stood a poor chance
against the riches of colour and the wealth of form
provided by the garden exotics. We wanted to draw
our plants with some freedom, giving them air and
light, and some decorative values, but at the same
time to conform to the title of our course. The
distinction between a good and a bad plant drawing
is hard to make . . . For nearly seventy years I have
drawn plants for love or necessity and have not
destroyed even slight sketches or notes in case they
should be needed for reference (publishers can have
an awkward habit of asking for illustrations in the
'dead' season). In any case, I feel a slight pencil
flourish even of part of a plant is more valuable
than a photograph. The open innocent countenance
of Daisy or Anemone may seem easy to draw, but
they too can be a snare, and sometimes I prefer
the hooded Labiates, helmeted Monkshood and
Balsam, or the leering countenance of Foxglove
and Penstemon.

Just as he was loath to part with his plant drawings,
so he was with the blooms themselves after they had
served their purpose in the studio. They would wither
away into brown sticks on the windowsills. Pots of
flowers, not so much arranged as perfectly tumbled
together by Christine, stood in every room. Enough
vegetables and fruit were grown to feed a large family

and village friends were accustomed to Christine's *cri de coeur* on the telephone, 'Please will you eat some of our beans.' The kitchen garden consisted of two large beds on either side of a little greenhouse which had once belonged to Eric Ravilious – 'He kept his bike in it.' To the north of the kitchen garden reared an enormous holly hedge, to the east a bank of old roses. During the summer it was very secluded and hot, a good place to eat strawberries while reviewing novels. Over the holly hedge one could see the top branches of a Victorian orchard, only one tree of which still produced a little fruit, a d'Arcy Spice apple tree, much cherished. And all across the garden, splashing or silent, were streams and springs and ditches, Bottengoms's own micro water-table.

So far as Wormingford was concerned, Christine's was a high and loved profile, John's somewhat clandestine and legendary. Both were everywhere, she where the people lived, he painting in the quiet half-lost dells and on the heights with their spectacular views of Suffolk, or fishing by the river.

It was the founding of the Dramatic Society in 1949 which was to make Christine such an integral part of Wormingford. Her training as an artist at the Slade before the First World War, her musicianship and knowledge of dancing, but above all her beautiful speaking voice, plus her love of young people, made her a fine actress and producer. The Village Hall had been

opened in March 1949 by Dr Thomas Wood and his wife St Osyth Mehalah. The Woods lived in Bures. Poor eyesight robbed Thomas Wood of what he might have achieved as a composer. Christine, who suffered from glaucoma much of her life, shared with him an ability not to let such handicaps ruin their lives. My only recollection of Dr Wood is being taught by him when I was a boy not to sing 'Heart*s* of Oak'. His father had been a master mariner and he was famous for his sea songs. Mrs Wood's parents, the Eustace-Smiths, lived at the Grove. Dr Wood had also been a great traveller at a time when very few people had travelled at all, had written a good autobiography, *True Thomas* (1936), and was a local celebrity. Just up the road from the Grove, running a market garden called Longacres, lived Guy Hickson, the brother of the future 'Miss Marple', Joan Hickson. Guy Hickson and Christine Nash, between them, were to develop the Wormingford Dramatic Society far beyond the usual village standards of acting. Photographs of their productions show a lot of the Bottengoms furniture and sometimes paintings by John, and Bottengoms itself became the costume department containing hundreds of dresses. Both John and Christine loved, or maybe understood, fancy-dress. Perhaps somebody should write about the passion for costume parties during the first decades of the century. The pinnacle of Christine's dressing-up activities were her and Mary Doncaster's exquisite 'Georgian Assembly'

at the Minories in Colchester, where we all wore actual eighteenth-century clothes in a series of *tableaux vivants*. She had borrowed mine from Miss Oates at Gestingthorpe Hall, the sister of Captain Oates the Arctic explorer, who had himself worn them at a fancy-dress party. They were the wedding clothes of a young man who was married in 1749. Christine's most memorable role was, perhaps, that of Lady Waldegrave in Winifred Beaumont's play *The Key* (1960). I used to read to her as she made her Tudor dress, the half-blind eyes so strangely 'seeing' when it came to needlework. Reading aloud at Bottengoms after dinner was a regular habit – John playing the piano while the meal cooked, me reading aloud while it digested. They liked L. P. Hartley, Ford Madox Ford, Henry James (*The Spoils of Poynton* was a favourite), and Jane Austen. They both smoked as I read, the low-ceilinged room eventually, what with the lamps and cigarettes, and the coals tumbling through the bars of the grate, growing stuffily cosy and much appreciated by them both because of this. Summer excepted, they deplored open windows. Cats sprawled on Christine as she cut out and embroidered. Often John would sketch, puffing away.

Summer was the very reverse. In a sense there were no rooms, no indoors, then. The garden was full of chairs and tables, and there was a constant carrying of things out. John wore a strange white peaked cap with a flap at the back to prevent sunstroke, and which he

called 'Rommel', and Christine fine print dresses and
straw hats. There was a litter of books, watering-cans,
paintboxes, letters, plates and glasses all over the
garden paths – there were no lawns proper – which
Christine used to edge with a pair of old sheep-shears.
They talked about the weather a great deal, tapped the
inside and outside barometers, and listened to all the
forecasts. Weather interested them, and they liked its
extremes, its drama. Should they be away during a
Wormingford gale or heatwave they wanted me to tell
them every detail. Precious plants had to be guarded
from frost or drought, and a long list of horticultural
dos and don'ts was handed to me just before John drove
off to paint in Scotland, Cornwall, or wherever.

John's work routine scarcely changed at all during all
his long career. A late-ish and what used to be described
as a good breakfast, then a slipping away to the studio,
where he'd paint from mid-morning until teatime. His
method was to paint watercolours and oils from lined-
up sketches made outdoors. The watercolours were
painted on a large old scrubbed kitchen table, and the
oils on an easel. He once told me:

I found that working outside and working inside
on one painting made a division of feeling about it.
There were the spontaneous strokes in the open,
and then, indoors, the intellect started to intervene.
So in the end I left that method and from then on I

have worked from my drawings, in which I indicate
form with washes of colour. Also, I like to work in
comfort. Outside, I see what I want to do by just
choosing my position. I don't alter things a great
deal. I make a practical drawing and if I want to
develop it into something larger I spread it out,
quite meticulously, so that every tree, field and bank
is in the place where I want it. When I'm on the
spot I suppose I'm rather like one of those sporting
dogs who is let into a field to flush the game. At
some point he stops and thinks, 'Ah, there's some-
thing here! There's something here!' And then
there is what they call the *genius loci* or spirit of
the place which has to be felt, and is felt. I also like
order in the landscape, and if I look long enough
I usually find it, though this is not to say that I am
emotionally cold towards what I am seeing and
painting. Far from it. Landscape often excites me.
Take the landscape round here at Wormingford and
nearby Essex and Suffolk, some would find it pretty
tame. There are no hills worth speaking of. A hill of
200 feet here is equivalent to one of 600 feet in the
Chilterns almost. Yet there is a subtlety about this
Wormingford countryside which I feel and see, but
which remains very difficult to define. It leads one
on a constant challenge. But if I have what they
call a private vision of it, then it is so private that
I hardly know what it is myself! You know, I never

look for more than the reality, the farming, the
trees, the river. I suppose the poetry gets into
the reality.

After Paul Nash's death in 1946, his paints and other
materials came to Bottengoms. Sorting them out told
John things about his brother's use of colour, and about
his own use of colour, which he had not previously
realised. It was a kind of revelation, a new understand-
ing of yet another way in which they differed:

When we were young we made it our business to
use good colours and permanent colours from a
purely businesslike point of view, and this forces
one to a certain palette. So Paul and I went for
the three-star, four-star colours according to the
colourman's catalogues. But we knew little about
them or what happened to these colours in time. I
was very surprised, after Paul died, when I went
through the great mass of paints that he had, how
very limited his colours were, not only in numbers
but in intensity. I shouldn't have thought that he
ever had such a colour as cobalt violet or rose
madder in his studio at all. My own palette was also
considerably limited. I'm not a brilliant colourist –
I'd very much like to be one! Other artists' use of
brilliant colour causes a certain envy in me. I have
to use a lot of variations of green in my landscapes.

As regards actual colours, I use about two blues, cobalt and permanent, veridian, a strong green which I usually have to tone down with yellow ochre, and combinations of yellows and blues. I also love the earth colours, Venetian red and Devon red-yellow ochre. The subtleties of the English landscape . . . are all very quiet and a limited palette serves one's end. I love old gravel pits and ponds; they can be quite a dramatic alteration in the scenery. I never pass up a good pond.

John liked company when sketching. Usually that of another working artist, Carel Weight in Cornwall, I remember, Edward Bawden in Shropshire and Derbyshire, and frequently myself in Suffolk. His personality alternated between long stretches of solitude in the studio and a sudden urgent need for conviviality. Our chief outings in search of the latter were to Benton End, Sir Cedric Morris's and Arthur Lett-Haines's famous art school at Hadleigh. Painting was rarely mentioned, it was always plants. Christine on the other hand preferred only the society of her few special friends, and disliked parties. The core of their social life during all the years that they were at Wormingford was a little inner circle referred to most affectionately, though with a touch of amusement, as 'the Dear Ones' ('My Dear One is Mine' – Matthew Arnold). In order to be practically and emotionally supportive, Dear Ones

had to be fairly near at hand or regular presences at Bottengoms. A number of them, naturally, were to be found in Wormingford itself.

As with so many writers and artists and composers, John's work pattern and discipline had been formed at the very beginning of his career and had changed little since. There was hardly ever a day when he did not paint or draw, play the piano or potter about his garden. In 1969 I wrote a BBC2 film about him called *A Painter in the Country*. It was directed by John Read, the finest of all the Corporation's art-film makers. It opened with a shot of John driving his car under a tunnel of leaves down to Bottengoms. But there was the Western Front to deal with, and some fifty illustrated books, and over a long and work-filled lifetime, landscapes of most of Britain, from Skye to St Austell, and collecting all the plants, and a thousand things for which Wormingford was but a base and a hub. But what a base and what a hub. Returning to it after a week or even only a day away, John would curse the ruts in the track and say, happily, 'Back to the old homestead!'

He died aged eighty-four in September 1977, just a few months after Christine. In the March of this year he painted his last watercolour from a sketch made in Skye. Their grave is near the holly tree in the far hedge of the churchyard, just above the footpath to Bures and that wide panorama of Stour and fields and woodland which had so pleased him for half a century.

As I stood with John on the autumn grass, he murmured, 'The garden is going, I am going.' Then, 'What will you do down here when I am gone?'

Prevent the garden from going. Write. Continue. What else?

When John was ten he was given a book called *Eyes and No Eyes*, which was about being observant whilst on country walks. It was full of lessons which he never forgot. Toward the end of his life he was to write:

> The artist's main business is to train his eye to see, then to probe, and then to train his hand to work in sympathy with his eye. I have made a habit of looking, of really seeing.

My main business at Wormingford has been to continue in my own way what went before, but on my own terms, and as best I can. With my youth crowded with artists, these last years are a kind of fulfilled silence in which a remote old farmhouse has collaborated with an unexpected enthusiasm. So I am fortunate. I too have made a habit of looking, of really seeing.

5 Fidelity

CAPTION: Fidelity Cranbrook and the Gathorne-Hardy children featured in *Let's Make an Opera*

In the early summer of 1955 I stayed at Great Glemham House for the first time; the Countess driving and asking shamelessly direct questions, swerving and laughing. Humphrey Repton had so planned the approach that one was halfway to it before it announced itself with Georgian panache. As we passed the pretty lodge Fidelity called out, 'Mr Paternoster!' Then came all the windows, roofs and frantic dogs. 'She doesn't bite – she just likes to give your ankle a little nip.'

The Gathorne-Hardys had come to Suffolk for the air just before the First World War. Their titles, Cranbrook and Medway, flowed happily enough alongside the Alde, which was a minor stream for the most part like the Lark, Linnet and Brett, where herons and kingfishers lived. Other than where they were bridged one would encounter them with surprise, having forgotten their existence. As country seats are inclined to do over the years, Great Glemham House had held back change, and the village and its fields, woods and lanes were still more or less exactly as George Crabbe, the rector, would have found them – although the previous mansion, a Tudor building, was set at the foot of the rise. He himself lived in Rendham, the neighbouring

village, from which at this moment Maggi Hambling drives to paint the Aldeburgh sea most days.

She explains this compulsion:

On the morning of 30 November 2002, I experienced a dramatic storm; huge waves crashing on the beach, thrashing the shingle. Back in the studio, while working on a portrait from memory of a London beggar, I looked out to witness the landscape around me still being ravaged by wind and rain. The urge to paint the memory of the morning took over and the sea supplanted the beggar on that canvas. This was the first of my North Sea paintings. They were small, mostly vertical oils.

Fidelity too had reason to go there and reason to come back. A day or two later I walked down the park to explore the village. There was no sign of conservation. The park was walled in for a mile or two yet wide open to anyone. There was a well-cut flint church, a basic Victorian school, a pub, and a handful of painted cottages, some outlying farms, and that was all. The scene was both intimate and yet remote. Acton, where I was born, was exactly like this – though growing. Great Glemham was not extending. Neither was it frozen.

Actually my very first introduction to it was in the evening when Jock Cranbrook took me batting. We went out at dusk to smouldering rubbish dumps to

watch these eternally misunderstood creatures weaving and crying over them. All Gathorne-Hardys were high up in natural history, books, the Bench, local government, horticulture, and chairmanship, whilst remaining amateur and 'free'. Fidelity was high up in tolerance and amusement. Her loud clear voice rose above the squalls. And most of all at the Aldeburgh Festival forays. They had made her Chairman from the very beginning, and it was one of their best achievements.

She was one of those classic inter-war blondes. Kurt Hutton would complain to her face about the strong line of her jaw, but I found her beautiful. Her tossing honey-coloured hair and her features, all eagerness, were quite wonderful. I can hear her laughing away all this with scorn. In retrospect I see her as one of those people who claim little because they know they have enough. She was a provider not a taker. Benjamin Britten, like the weather in the psalm, might rage, but Fidelity alone could call order. 'Fidel! Fidel!' Jock would shout. As there was nobody to answer the bells at the big house the two of them had acquired intimate raised voices. Quakers were practical and knew when to abandon quietness.

Jock had organised the bicentenary of George Crabbe two years before I arrived. It was now in his mind to let me have a cottage, make me a churchwarden and generally settle me. I can't remember there being any consultation with the PCC. Taking me to the church

he told me about Crabbe's Sunday habits. How in the darkening winter afternoons the poet would climb onto a seat by the window and cry, 'Upon my word I cannot see – I must give you the rest when we meet again!' And how when his tithes were due, he would climb down from the pulpit and say, 'I must have some money, gentlemen.' Jock was a famous bat man both in Suffolk and in Borneo. These creatures had been so absurdly fantasised by humanity that they needed an informed protector, and this was Jock Cranbrook. Bats are mammals which fly like birds. They tell each other where they are by means of echo-location. There are Greater bats and Lesser bats, the last with horseshoe-shaped nose leaves. And there are the delightful pipistrelles, the long-eared bats, and bats which like to fly over water. It was chilly searching for bats, even over bonfires; and we rubbed our hands. They flew very near to where George Crabbe had made a bonfire of his three novels. He must have had a double dose of laudanum that day to have been so reckless about it. There comes a moment in many novelists' minds when they think of striking a match. Now and then we would poke the embers with a stick to make them flare.

Being a 'what's mine is yours' person, Jock gave me free run of his library. 'Read away, Ronnie.' Just after harvest he and I would climb up ladders to the grain silos and run the cornseed through our fingers, testing its fullness. On warm days I wrote in the walled garden,

getting on with my novel, haunted by long-dead gardeners, armies of them. Their glasshouses and potting sheds; their serried rakes, spades and scythes hung on the wall in working order. There was a captured quiet and every now and then a briefly captured bird, like the gull in Mary Potter's painting at Crag House. In spite of all this, at heart I was directionless. I could hardly explain this, it was so ungrateful. The young people in my novel were in a similar plight, or should we say interesting situation. I called it *A Treasonable Growth* from Wordsworth's confession in *The Prelude*: 'And most of all, a treasonable growth of indecisive judgements, that impaired and shook the mind's simplicity.'

There were five children at Great Glemham House, Gathorne, Hughie, Juliet, Sophie, and Christina, whose godmother was Christine Nash. Ben had written *Let's Make an Opera* for them, a William Blake chimney-sweep tale. I saw wherever I looked an interplay of life's actuality, hopes and fantasies. It all seemed to work when Fidelity was around. Her husband, borrowing 'a fiver till Thursday' from the butler, would speed off to the County Council or the House of Lords, while she would say, rather like Christine, 'Now, where would you like to write – we mustn't freeze the muse.' And I would make myself scarce in the walled garden when it was fine, or into my bedroom if it was not, in either corner out of place. Yet the pages piled up. There was so much

going on that it was hard to know what to put in or leave out.

Only fragments of what recurred there half a century ago hang around in my head like the dislodged tesserae of a once elaborate floor. One complete memory of all is the music. Concerts usually took place on summer afternoons in the drawing room. The audience spilled out onto the terrace. Stack chairs, the scent of tea. Heavy curtains into whose pelmets it was rumoured Jock had encouraged bats. The faint Sunday sounds of rural 'rest'. Benjamin Britten had set some of Arthur Waley's translations from the Chinese. Julian Bream played and Peter Pears sang. In the kitchen Hephzibah Menuhin and I tiptoed around setting out a hundred cups, and sometimes we crept to the door to watch as well as listen. Many of the songs were a thousand or more years old. Each one of them brief and fleeting. After an hour, maybe, came the ritual applause and bows. Ben left hurriedly; brushing past us on his way to the kitchen he muttered, 'Pearls before swine', but with a grin. Hephzibah and I looked at each other like people who have made a wrong judgement – who had not understood. Yet ever since, this Chinese/Suffolk singing has never left my ears.

The audience was released into the garden, all chatter and teaspoons, and more like freed chickens than swine. But who can say what is heard and not heard, felt or not felt? Before going to bed I looked up Arthur Waley in

an anthology. When is the translator the poet? I read his version of 'The Temple' by Po Chu-i, which is a kind of Chinese George Herbert narration in which the poet makes a pilgrimage over pebbles to a place called the Settled Heart Stone. It is close to where Buddha preached his sutras and where the first monastery was founded. Peter Pears's wailing voice led us to it, although in other 'pathway' words.

Benjamin Britten, like myself, had been drawn into the magic of Great Glemham House from the very beginning. The early Festival itself was made up in these rooms. There were photos of Ben – Shetland sweater, Peter – cricket jumper, Imogen – nameless skirts, and Eric Crozier – open-necked, in a circle of armchairs. And of Fidelity herself giving them anything they needed which she possessed.

The notorious rift when Eric Crozier would no longer be part of the circle was the only thing which was never explained to me. Not that I ever asked. His words are sung to so much of Britten's early music, and his advice to found the Aldeburgh Festival had been so right, had resulted in such a successful venture, that his sudden absence made me pensive. He and his wife Nancy Evans lived in a cottage just behind mine. Our gardens came together in a pointed hedge, and we would talk through the leaves, when I would sometimes sense a great hurt and fury. It would be years later when I was working on an anthology of the Festival's

quarter-century existence, and I came to Eric for information, and when he called several times to see if he was included, that the size of the injustice done to him became apparent. Yet he did not explain, and his look forbade me to ask. Did he see in me a loyalty to the Britten and Holst camp? 'How strange of you not to ask outright what had happened,' people say, 'you being neighbours.' But my not knowing was a kind of benefit. He and I and Nancy remained, rather absurdly, 'next-door neighbours', and we gave each other fruit and veg over the hedge. I complimented Eric on his libretto for *Let's Make an Opera* in which he and Ben had put all the Gathorne-Hardy children. Also on his words for Ben's *Saint Nicolas* cantata, in which I had sung when it was first performed in Aldeburgh Church.

There would be other blow-ups anon. People going off like the Maidstone gun. Fidelity's scathing sanity. Not to mention her frank enjoyment of the tantrums. And always, behind this, her enduring love.

6 Meeting Ben

In May 1955 Mr Cullum the bank manager sat me in his office to scold me for being £25 overdrawn. I told him that a cheque for this amount was on its way from the *London Magazine* but he was not assured. No more for me from Barclays until I was cleansed of debt. His son Jeremy was Benjamin Britten's secretary and tennis partner, and Mr Cullum himself was the lover of Elizabeth Sweeting, the Festival Manager. Unbeknown to me, debt and probity were filling the arts at this moment. The Festival was overdrawn, like me, and Elizabeth, who was salaried, was having to leave. Some other method of running things was being discussed. After my interview I went next door to the baker's and there met Juliet Laden who, seeing my worried face and hearing of my penury, at once wrote a cheque for £25. Returning with it to Mr Cullum, I expected joyfulness. Instead I received an even more anxious look. Not only was I the kind of new customer who was going to bother him, but a swift borrower to boot. He was now worldly-wise in Aldeburgh ways, the insecurity of people like myself, the flimsiness of our lives. But he was impressed by the signature. It reminded him of another new arrival, the divorced wife of Sir Francis

Cook, now Mrs Laden, who had bought Brudenell House. The next morning the *London Magazine* cheque arrived. I mention these parsimonious facts because they somehow reflected 'Aldeburgh' in miniature at this moment, the scarcely now believable finances, the give and take, the wildly imaginative plans both to do our own work and also to run a unique music festival, now almost a decade old. Could it go on? This question was openly asked.

The solution was to replace the salaried Elizabeth Sweeting with the unsalaried Stephen Reiss who would be called the Responsible Organiser, and myself as his assistant at £150 per annum. What poor Stephen needed was not a young man who had run a literary society and hung a John Constable exhibition but a competent office worker. What he got was a financially illiterate novelist. My interview burns in my memory to this day, each minute of it fixed. The coming into the same room where a few months earlier I had worked on Morgan's biography of his aunt, the woman who had saved him from having to get a job of any sort, and standing before Benjamin Britten, Peter Pears and Stephen Reiss, the latter blinking through his glasses. Fidelity Cranbrook introduced me, she having been told by Christine Nash what a good arranger of lectures I had been in Colchester.

Ben and Peter were in shorts and I was wearing my tweed jacket and green corduroy trousers, and a tie.

They stared gently at me. Stephen stood in the back-
ground, an *éminence grise* to be. It would be brilliant
whilst it lasted. Fidelity laughed and tossed her hair. I
could tell that she had been told a lot about me, the
Nashes and the Cranbrooks having been close friends
since the Thirties. Country life, botany, and fishing
especially had long bound them together. What with
Cedric Morris and Denis Garrett, birds and flowers,
landscape and agriculture were stalking me in all direc-
tions. As Britten could only love or hate, it was said, and
did not possess a detached view on anything or any-
body, I suppose he should not have been present. But
he was present and would be at even the most mundane
affairs affecting the Festival. The question at this moment
wasn't so much 'Can you help?' but 'When can you
start?' The room was dominated by bare legs, Peter's
so white and plump, Ben's so ochre and knobbly. Doors
were wide open fore and aft and a fresh breeze poured
from the sea into Crabbe Street. So that was that.

'Say goodbye to Elizabeth Sweeting, would you?' said
Lady Cranbrook. 'She would like to see you.' I had read
her name on the first Programme Book. I found her in
a little flood-stained room behind the Wentworth Hotel.
The box files were marked with water. Two years
earlier the mighty winter sea had broken all barriers
from Canvey Island to the Wash, drowning many
people and animals. Benjamin Britten himself had
helped in bailing out Crag House and boats had been

rowed down the High Street. Five years later *Noye's Fludde*, Britten's setting of the Chester Miracle Play, would fill Orford Church with Suffolk schoolchildren in a storm of sea music. Britten had remembered the carved ark on the Duke of Norfolk's tomb at Framlingham, the many drowned sailors in Aldeburgh churchyard and the winter of 1953 when the North Sea filled his rooms. He had brought them together in a ferment of waves, hymns, terror and salvation. Amongst the guilds which traditionally re-enacted the drowning of the world in Genesis were the Shipwrights, Fishers, and Mariners. As with all Miracle Plays, *Noye's Fludde* was performed, not during winter when real water would have passed through coastal towns, but at Corpus Christi in warm sunshine.

It would not be the sea which drove Britten from Crag House but its seasonal celebrants who would stand on the wall and watch him at work. He and Mary Potter exchanged houses the same day in 1957. I saw the pantechnicons pass each other. But for Mary it was a wrong move and soon she would be back at the Red House, the perfect third person. When Stephen Potter left her Ben said, 'Now you must call yourself "Mary, Mrs Potter".' My first glimpse of her work was a big oil in Crag House showing a momentarily trapped seagull in a walled garden – presumably at the Red House. It was as much poetry as painting. Her art was shadowy, haunting, carefully unemphatic, though real and not dreamlike.

Seeing me glancing at the watermarks in the Festival Office, Elizabeth Sweeting said, 'It was terrible!' I noticed an element of thankfulness regarding her departure. We sat amongst the litter of her going. Mr Cullum the bank manager was furious at the plan to exchange her with Stephen Reiss. When she arrived Lord Harewood had hoped that the Festival would 'belong to Aldeburgh and Suffolk in the sense that Mozart did to Salzburg'. When I arrived it lay to Stephen Reiss to achieve this. He appeared somehow hidden and yet powerful.

I should here say sorry to Stephen Reiss for not earning my keep. Also tell him how great he was in Aldeburgh terms. A rescuer. A rock. There were moments when the Festival would have foundered had it not been for him. Somehow tragic in himself I thought, he knew how to bring light into dark corners, to be strong when everyone and everything else went to pieces. He had come from the New Towns in Hertfordshire and possessed a Shavian common sense, and a way of crossing awkward boundaries. This was also Fidelity's Quaker territory and between them she and Stephen held their sensible ground in the frequent tempests of the Festival.

I was too turned in on myself at this stage, not to say too awed by Ben, to recognise Stephen Reiss's greatness. Fidelity Cranbrook's understanding of it was all too plain. She would observe me as I took it in – or

failed to understand what was being said. The fact was that I wrote and wrote all day, read and dreamed. Words made a screen through which every other activity was filtered and made a kind of grudging entrance. All the same I found it impossible to call myself a writer. The first person to do so was Imogen Holst. Not even Christine Nash could do more at this stage than to tell people that I had gone to Aldeburgh 'to write'. The stress must have shown because Ben asked, more than once, 'Are you happy, Ronnie?' He let off steam with strange war whoops. 'Middle class, Ronnie; middle class!' And, 'I'm thirteen!'

I suppose I must have sounded confused at least to the old friends, James Turner, W. R. Rodgers, and R. N. Currey, all established poets and a generation older than me. One of our group activities had been to read George Herbert in country churches. Another was to think of ways to make book programmes for the BBC. The Third Programme had just been invented and 'Bertie' Rodgers was one of its stars which astonished us as he was rarely sober. And always broke. Yet he invented something called the Rodgers method of radio biography in which wonderful sound-portraits of Irish writers – W. B. Yeats, Lady Gregory, George Moore, and Æ – would be heard.

Bertie would appear in Aldeburgh now and then, always immensely late for the lunch I had spent all the morning cooking, he and his Danish wife Marianne. His

soft weary voice suggested a conversational exhaustion. The fact was that although he never stopped talking he never stopped listening. Conor Cruise O'Brien said that Bertie's eyes were 'large, prominent, lustrous, suited to a hypnotist, or a Swami. They also seemed to be, in some strange way, turned off, not looking. He listened like a blind man.' And there was something 'a little pastoral, as well as a little clinical' about this listening which made it disconcerting. Although one eventually told him anything and everything, the distinct fastidiousness of his nature prohibited shapeless outpourings. He would say that men and women were 'as honest as the day is long, and no longer'.

He enters the Aldeburgh scene at this point because, listening to my diatribe about money, he promptly solved everything by whispering over his drink, 'You must be a publisher's reader.' Thirty shillings a report. He sent me off to Ian Hamilton. The only person I knew who wrote about being a publisher's reader was William Plomer. And he was part of the Aldeburgh scene. He and Ralph Currey, my other Colchester poet, were South Africans. Bertie Rodgers in the Aldeburgh pubs was a sight to be seen. But not, as the beer disappeared, always a voice to be heard as it grew softer and softer.

'Can you hear me, Ronnie?'

'No, Bertie.'

'If you'd had the drink you could.'

Observing Bertie Rodgers, I began to observe myself. Shouldn't writing make me look for his philosophy – or at least something akin to his temperament? Whether listening to friends or enemies, he worked on the principle that everybody's stories were fine if he thought that the speaker himself believed they were. Balancing the vanities and the decencies of human nature, Bertie arrived at his kind of accuracy by means of give and take.

When my father died in 1957 I gave Bertie his Donegal tweed suit. He looked fine in it. When I wrote *Akenfield* Bertie gave me Rider Haggard's *Rural England*. But what he most gave me that first year on the Suffolk coast was a sense of inclusion. Our mutual friend James Turner did the opposite. He believed that Aldeburgh would corrupt me. That going there was my initial error. He is 'the Poet' in *Akenfield*. As I couldn't possibly be like Bertie Rodgers, then I must be like him. But the brief time there would make me unlike either of them, or anyone, unless in some strangely hoping way, at least at the beginning, like Imogen Holst. An absurd comparison of course. When I told Christine Nash this she didn't flinch. She gave me furniture to make the flat which Imo found for me by pointing to an ad in the house agent Tuohy's window, and said that all she asked of me was to *settle*. With whom? was what I was thinking. The question was deep down preoccupying. Imo herself had settled in a flat above Tuohy's.

Life at Crag House was most unsettled. People came and went, doors were never closed, cars went back and forth to Saxmundham station like rockets. Mr Baggott at the newsagent's was selling postcards of it and gawpers stood on the sea wall. It was unbearable. But Miss Hudson, the housekeeper, produced meals whatever the number round the table with a bewildering efficiency. Imogen had a three-and-sixpenny lunch at the Cragg Sisters' restaurant every day. I lived on herrings and bread and counted pennies – even when the publisher's reader fortune began to pour in. My first manuscript was *The History of the Pig*. But then an American magazine paid me a hundred pounds for a short story. When I took it to Barclays bank it was taken to Mr Cullum, who peered at me through his door. I went to the Thursday sale at the scouts' hut and bought things for the flat with it.

Working on the Festival finances with Stephen Reiss at eight o'clock each evening I recall how we would keep our lives separate and stick to the task in hand. Beth, his wife, would bring us coffee or a drink. The – to me – fairly incomprehensible papers would be sorted and filed, the Guarantors would be given first preference notification of seats, the Subscribers second. Stephen spoke softly and blinked through his glasses. He remained both ponderous and light-fingered, the pile of letters disappearing with speed plus heavy remarks. About eleven he would walk me to the pub corner and

pass over a fat bundle of correspondence for me to post. I knew nothing about him. Later, I would be told how he would move from project to project with little explanation. One of his moves was from Balliol College to Chelsea School of Art. His main task while we were working together on the Festival was to write a book on Aelbert Cuyp, the Dutch master of landscape with cows. Long after our meetings he would promote the work of my friend Peggy Somerville. He had – like Britten – been to post-war Germany in its ruin, and had been in charge of the cultural rehabilitation of Lubeck and Schleswig-Holstein. And like Kurt Hutton and Leon Laden, his eyes had not cleared from what he had seen. He moved swiftly when important things needed to be done, out-running committees. It was Stephen who saw the Snape malthouse as a wonderful concert hall, and who took *Idomeneo* to Blythburgh Church within hours of the Maltings Concert Hall burning down. The Festival seemed clogged up with committee matters but Stephen often left them behind, thinking as he did on another plane. This agility wasn't present in his face, which was pale and sad. He would last a long time. Britten dedicated *A Midsummer Night's Dream* to him. His carrying the Festival from Aldeburgh to Snape was momentous. And all achieved with a bewildering cut through bureaucracy. He fell from grace in 1971. The departure, though cataclysmic, was described by Stephen as a 'difference of opinion'.

It was in 1971 that Peter Hall wanted to film *Aken-field*, a project which filled me with fear. We met for the first time in London. The book had upset him. It was as though he had encountered his ancestral Suffolk for the first time. He encouraged me to write a film treatment of it. The producer Rex Pyke gradually persuaded me that it could be done. I recalled a boyhood picture named *Man of Aran* directed by Robert J. Flaherty. And what was more, that my farmer neighbour at Great Glemham had acted in it as a sixteen-year-old. This in the Thirties. It was about a kelp economy on an Aran island where seaweed was inned with monotonous toil to make slippery fields. I also remembered Pier Paolo Pasolini's masterpiece *The Gospel According to St Matthew*. The two films together were what finally persuaded me to go ahead with the Peter Hall film.

Peter Hall knew that funding such a film would be almost impossible and he began to see it as a triple venture by me, Benjamin Britten, and himself, all Suffolk-born men. In July 1972 I wrote fearfully to Britten, well aware of his dislike of film crews, telling him that the *Akenfield* film as created out of my book, which he had read enthusiastically, would be a kind of Thomas Hardy story. Britten adored Hardy and had set a number of his poems. But I added Robert Bresson and Pasolini to my persuaders. Greatly daring, for Britten detested suggestions, I said, 'It would be a very serious film in which Peter Hall and myself will be absorbed as

people coming from many generations of Suffolk country people. It is a low-budget film, and except for perhaps two or three leading characters, will use real people and not actors' (in the long run the leads were also locals). I had already had a talk about the film with Britten's publisher, Donald Mitchell. Thus I continued, 'It was immediately evident that we could not ask you to provide such film music in the ordinary sense. Instead, Donald told us of some unpublished music which exists which, if it could be extended, would be perfect for the film. Our plan would be to fit parts of the film to this music, and not to request you to write to the film. There is plenty of time, as the film has to be shot over the seasons . . .' I went on that should Britten consent to this arrangement, the London premiere of the film would be used to raise money for the Snape Maltings Foundation.

What I do remember now was Ben's dislike of other people's projects. Twenty years earlier I had told Imogen Holst about the Quaker James Parnell, a hero of mine, John Nash having agreed that he would be the perfect subject for a Britten opera. Not that I would have been so presumptuous as to suggest this, but only to tell him a story which I knew would enthral him. I often told him tales. He would watch my face. This was the story about a teenage Quaker who had been murdered by the gaoler's wife in Colchester Castle during the late seventeenth century.

Meeting Ben

At Colchester, in the Norman castle built of Roman bricks, and which rises from the floor of a temple dedicated to the Emperor Claudius, who was a god, there is a fireplace recess just by the entrance in which James Parnell, an eighteen-year-old who had preached to people as they left church on Sunday mornings, had been imprisoned. Parnell called churches 'steeple-houses' but apart from this he was peaceful and polite. But in Colchester particularly there was a rage against the Society of Friends and the mayor himself, with a band of Quaker-persecutors, would set out in the evenings to rout them out.

James Parnell had been converted to Quakerdom by George Fox. He had walked from Retford to Carlisle to meet him, this 'Older in the Truth'. Captured, he was exhibited semi-naked in the fireplace at Colchester prison by the gaoler's wife, and she and her friends would stand around to watch him climb down a rope to the floor for his food. Eventually, weak and ill, he fell, then died. The magistrates brought in a verdict of 'suicide by fasting'. 'I have seen great things,' the dying boy told the embarrassed crowd.

At Friends House in Euston Square there is no doubt that he would have been a great writer. To me Parnell is a saint. I 'hear' him speaking and maybe singing. When I was taken to the new Meeting House at Bury St Edmunds I enquired, 'Do Quakers sing?' 'If the spirit leads we do.' So I hear music when I think of this

martyrdom. I would like to have talked to Ben about Quaker song.

One day I told this story to Imogen who guessed that I would tell it to Ben. We were working in her flat. Her alarm was real.

'Oh, you mustn't, dear. Promise me you won't! He *hates* suggestions. Oh, please don't tell him!'

'I won't, Imo . . . I won't. I understand.'

Although I didn't, not at that moment.

This ancient panic about not making any suggestions caught up with me as I wrote to Britten about Peter Hall's *Akenfield* film. But he was easy, businesslike and approving. 'What a good idea. Come over!' So I introduced Peter Hall to him. I don't think that they had met before. Peter, Ben, and I and perhaps Peter Pears and Rex Pyke, sat on the Red House steps in sunshine. Ben was easy, seemingly very happy, affectionate. He and Peter Hall got on well. Much later Peter would direct *Albert Herring* at Glyndebourne – with Suffolk accents – but now he was in imaginative full grasp of the nature of the *Akenfield* film. It would be Pasolini in Suffolk. Later Ben and I had our ritual walk round the garden.

The outcome of all this would be as tragic as Parnell's brief existence. One of the countless ways to raise money for the Snape Concert Hall was for me to anthologise the twenty-five Programme Books. They were remarkable and nothing quite like them existed in the concert world. Beautifully and individually

designed, printed on good heavy paper, filled with East Anglian natural history as well as architectural history, gloriously illustrated by Kurt Hutton's photographs, and with drawings and paintings, they were a Suffolk library in themselves. One morning John Jacob, now the Festival Secretary, arrived at my house with a carload of them and everything pertaining to them and told me, 'Ben says make a book from them.' There was the customary Aldeburgh hurry to get something done by yesterday. And there would be a hundred signed copies at £10. Ben said, 'Who is going to pay £10 for a book?' Faber Music, Britten's publisher at the time, published it in 1972, and Ben, Peter, Imogen and I sat in the Festival office for hours, pushing the special edition from hand to hand as we wrote our names. It was a lovely day with the sun blazing through the windows and the sea benign.

Afterwards, coming down the stairs, Ben allowed Imogen and Peter Pears to go ahead. Then he said, 'I can't do the *Akenfield* score. I am ill. I have to have an operation. I'm sorry.' I noticed that his usual lined face had been smoothed out with cortisone or some such drug. I was shocked. I didn't know about his heart. We walked along the Crag Path in silence. The towers were as normal. Fishermen lounged as usual. The gulls cried perpetually. After a few steps he hugged me and went ahead. It was the last time I would see him other than as the grey shade at the rear of the brick Artistic

Directors' box in the Maltings, where, usually in an overcoat, he would enter just before the performance, the ghost of his own reality.

When Denis and Jane Garrett and I went to Snape we would walk through the reedbeds to Iken, where St Botolph had his cell. All the way there was reed-whispering, and now and then the noisy rise of a bird. Britten had a hankering for his grave to be made in these reeds but it was out of the question. So much water. Thus Bob and Doris Ling, caretakers at the Maltings and before that gravediggers, compromised by lining his grave in the churchyard with these now still reeds. I never walk to Snape along the Sailors' Path without hearing the music of *Curlew River*. There was initial consternation when Peter Pears sang the part of a woman looking for her son but the sometimes curious pitch of his voice, the loneliness and hauntedness, made it a memorable choice. These reed marshes make the sea appear far away. They create an optical illusion through which the old thatchers would chop their way. In and around them there would be constant toil. They set oriental standards in Suffolk, and, like the Fens, they promised poor health for their toilers. But the east winds seem less bitter there. These reedbeds and their subsequent marshlands have made a contrasting coastal universe, each with its separate sounds and climates, each with its scuttling occupants. Britten would wander along the wet paths, his curly head coming and going

through the dense reedheads. He liked company on his car jaunts but here he would usually be glimpsed walking alone. This, and on an Aldeburgh marsh, was where he got away. Although crowds were part of him. He was gregarious by nature and often he seemed to thrive in company and to find his own silence within it. This would amaze me.

The doctor had told Ben that he could complete his *Death in Venice* before the heart operation but nothing else. The operation was a disaster. He was fifty-nine. I was looking after John Nash when Britten died in 1976 and we watched his funeral on Anglia Television as it climbed up the hill. The hill which he would almost run up to meet Imogen when she briefly lived at Brown Acres behind the church, and up which she walked to bring me a cake. 'It's your birthday!' or 'It's my birthday!' Although it was neither.

Peter Hall and I sat on the grass at Charsfield thinking whose music we should now have for our film. He had a cassette player and we listened to a bar or two of Elgar's First Symphony. No. Then he said, 'Do you know this?' It was Michael Tippett's moodily brilliant *Fantasia Concertante on a Theme of Corelli* and its suitability caused us to scramble to our feet with relief. It was perfect.

7 Blythburgh

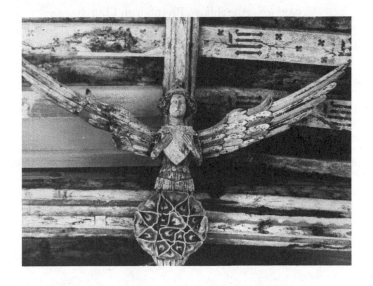

It must have been as late as May, and perilously close to the opening of the Ninth Festival, when we were all at a Council in the Moot Hall, that it was decided a concert should be held in a church other than Aldeburgh. The clergy were still not used to such events and it was tempting fate. But Ben had Blythburgh in mind. If we were to be expansionist, where better to begin? Holy Trinity was itself a weathered work of art of unique beauty whose unknown creators we thought would make common cause with our aspirations. With only a few weeks to go, and everyone eager, how could it be done without upsetting the Reverend Arthur Thompson? He had been vicar there for close on forty years and might not wish to be disturbed. A letter? – too perilous. A telephone call? – impolite.

'We'll send Ronnie,' said Ben.

Nobody offered to drive me to Blythburgh, so I went on the bus. When I got there it was to find that the vicar lived at Walberswick. I walked across the common in glorious sunshine. All the birds were singing and the may was out in frothy abundance. Mr Thompson had not been told of my embassy so he came to the door

polite but puzzled. He was elderly and rumpled and faintly alarmed.

'The Aldeburgh Festival,' I repeated.

'Is it a band?'

'Sort of,' I said.

'In my church?'

'It would of course be sacred music.'

He left to make us a cup of tea and to think before he answered.

'You say next month – June?'

'We would love to hold the concert then, sir.'

Much more thinking, then, 'I don't see why not.'

But there was hesitancy. Scared of returning to Ben and Stephen Reiss without a contract, and seeing that Mr Thompson was the kind of man who did not sign one, I plumped for 'Perhaps you would like to ask the PCC?' At which he exploded. He could do what he liked in his own church – 'Never mind them!'

'You wouldn't mind us filling the big space at the back with extra chairs?'

'Do what you like.'

My relief and gratitude and grin made him laugh. 'You'll do,' he said. He walked with me a little way. 'It's a pretty place, isn't it?' he said. When I returned Stephen rang up for stack chairs from the Education people and I sat with Imogen in her flat putting the Blythburgh programme together. Her Purcell Singers were to present Palestrina's *Stabat Mater*, Purcell's

Magnificat, Priaulx Rainier's *Requiem*, Thomas Tom-
kins's *O Pray for the Peace of Jerusalem*, and Bach's
Komm, Jesu, Komm. A substantial glory. Imogen was
immensely excited. 'Oh darling, darling!' We had
scrambled egg on toast.

This first Blythburgh concert brought me close to
David Gascoyne, whose poem was set by Priaulx
Rainier in her *Requiem*. I remember finding one of his
lines, 'darkness that burns like light, black light' a
brilliant metaphor for the Marian flushwork although,
he said, it had not occurred to him at the time. It would
be many years before we saw each other again. He had
come to Essex University to receive an *hommage* in the
form of a collection of poems by Seamus Heaney, Ted
Hughes, and other contemporaries which I had to
present to him at the end of a reading. He was over-
whelmed and in tears. Our last meeting, in October
1983, was standing outside Marks and Spencer in
Colchester High Street, with the crowds milling round
us. He had been to see Cedric Morris at Benton End. I
had been reading his *Paris Journals*. He gave me a little
conversation about ageing, posting it to me a few days
later. It was called 'Sentimental Colloquy':

The evening in the towns when Summer's over
Has always this infectious sadness, Conrad;
And when we walk together after rain
As darkness gathers in the public gardens,

There is such hopelessness about the leaves
That now lie strewn in heaps along each side
Of the wet asphalt paths, that as we turn
Back to the gardens' closing gates, we two,
Though in our early twenties still, seem elderly,
Both of us Conrad, quietly quite resigned
And humbled into silence by the Fall . . .

Blythburgh became one of my dream places after the
1956 concert. I would cycle there and take up a kind of
residency. The amazing church was a product of the
strenuous piety and unfounded optimism with which
the Middle Ages closed. Its wealth came from the sea.
It stood above a fishing port and took its tithes from the
herrings. These had to be eaten twice a week as food for
fasts. When the Reformation banished this holy diet the
church lost its revenues. Poverty, and not holy poverty
by the sound of it, made itself felt. The River Blyth
silted up, as did the harbour, and the not all that showy
tower no longer looked down on boats, but on nothing
which it had been built to recognise.

Yet the body of the building retained its splendour –
time even added to it. The long arcade stayed assured,
each downward tracery pencil fine, the repetition
perfectly controlled. Blythburgh is a Job of a building,
an architecture which has gone through every hazard
before arriving at its current splendour, thunderclap
and all. Its quality is not unlike one of those lustrated

ventilation bricks which have been laved by the sea –
sucked smooth by it but retaining its purpose. Inside,
the roof is very high and white and stencilled all over
with green and crimson flowers. Everything is faded to
perfection. Angels bear down on one from a safe height.
They have been shot at – winged – yet still they soar. It
is best to lie flat on the floor to watch their flight. They
carry their wounds like martyrs. Their pinions beat the
wooden sky. They sing eternally, 'Komm, Jesu, Komm',
only in late Gothic.

There was rarely anyone there for this was a pre-
Pevsner time and before Philip Larkin had written of
'Church Going'. But one day I found a young man in
his coffin. About my age, his plate said. He lay on tall
trestles in the chancel. I sat with him for an hour. I said
it was too soon for this. A woman arrived and swept and
dusted around him.

Sometimes during these flights from novel-writing
and Festival planning I tried to enter the medieval
mind. It proved impossible. Trained historians and my
wildly untrained conclusions got me only so far. Then
a curtain was drawn. The thinking, language and usage
of the materials which had constructed this place
refused to cohere. I was left with what the Suffolk his-
torian Walter Copinger said, what Julian Tennyson
said, what M. R. James said, and not what its priests and
carpenters said. It arose from convictions, patterns and
fancies so unlike mine that it was useless to proceed

other than via Perpendicular and Decorated. Many years later writers such as Eamon Duffy, using the Reformation inventory of Long Melford Church, would take me further into Blythburgh than seemed possible at this moment. Even now the average parish church guidebook puts the cart before the horse. It deals confidently with architecture and its materials, stone, wood and glass, but sketchily and rather apologetically with what it terms 'Symbolism', the word it uses for Faith. It was this which expanded Blythburgh beyond its actual religious requirements. Everything went into it, from mystery to the mundane, from sex to immortality. As for poetry, this simply descended like Portia's mercy. And will do so for as long as its arches stand.

These were the things I felt as I sat on each behaviourist bench in turn, made aware of the late medieval bottom and eye. I felt and saw to a feeble extent the pains and pleasures of the saints, and listened to the unfamiliar tellings of familiar stories. Earthly and unearthly love came together. I even imagined a long-unheard music being drawn down by music which would not have been heard here since the time it was composed. There are moments when what is ancient becomes bright and new. It is like propagating the seeds found in a sarcophagus.

I found that an essential difference between the medieval mind and our own was that it was incurious. It explored, amplified, decorated and taught only what

it knew. The great heresies themselves did not set out to provide another or better world. They grew out of the same inventive passion for life which produced Blythburgh, or Chartres Cathedral. There was no line between what was sacred and what was secular, but only a terrifying divide between heaven and hell. These were as geographic destinations as Rome or Ipswich, signposted and eventually reached.

Once, trying to make contact with those who sang and spoke in Blythburgh Church, or swung on rope ladders fixing angels, I read Chaucer's *Troilus and Criseyde.* The Chaucers originated in Dennington not far away. Britten loved this church. He took young friends there and they wrote their names on the sand table – 'Benjamin Britten' – then obliterated them with the smoother. Dennington was a church where little had been turned out and where, like Blythburgh, there was much evidence of the counting of the hours. Time as both villages knew it still clunked away.

During the drastic nineteenth-century restoration of churches, when more damage was done to medieval architecture than by time and decay, William Morris used Blythburgh as a model for bodging. Such old buildings should be patched not 'restored'. Aged twelve and seated next to his father, Morris would let his gaze roam around Canterbury Cathedral as he searched for the partnership which had made it, heaven-liness and human-ness. Morris's century was still an

age of 'hands', or the workforce stripped of its person-
ality, and at its worst turned into mere operatives by
Gradgrinds. In spite of this, William Morris saw hands
which had created Canterbury Cathedral on every inch
of its stone, glass and wood, which was why the
building *lived*. It was his conversion, the birth of Arts
and Crafts, and for him the death of 'Progress' via the
machine.

For me at Blythburgh there were days when the
medieval voice became positively colloquial, and the
medieval artistry cheerfully workaday. Knight, artisan
and peasant, priest and layman talked a lot here. What
I 'heard' were Suffolk country voices and an awakened
or recovered singing. I read about the Courts of Love
presided over by Eleanor of Aquitaine which were music
schools amongst other things, and whose ideals were
carried from kingdom to kingdom by singers – trouba-
dors – and whose arts became part of the liturgy here.

Johan Huinzinga said that aristocratic life in the
Middle Ages was a wholesale attempt to act the vision
of a dream. What remains at Blythburgh is what
remains of the freezing of this dream. What the
builders set in stone, wood and glass, even in broken
brick, should explain what they had in mind. Yet it
cannot. And this is its wonder.

8 Imo

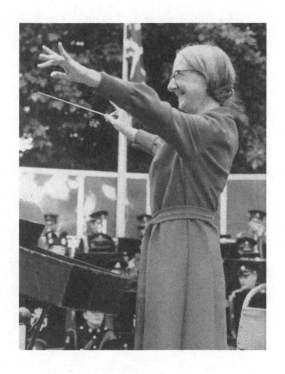

CAPTION: Imogen Holst conducting

After my duties for Stephen Reiss had been transferred to Miss Flo Powell, Imogen Holst took me over. And never was there a more sensible arrangement. Imogen had a long experience of assistants. Her treatment of them was a kind of authoritarian love. In 1955 she was forty-six but had taught so much, travelled so far, been Ben's saviour for three amazing years, that she possessed a greater authority than she realised, and had little idea of the effect she had on me. Everything she said or required was like a gift. The plainness of her face was itself so total that it had become beautiful. Her voice was modulated, her laugh raucous. She liked men and was used to them. She had no notion of work time and leisure time, and she made me have no notion of these opposites either. We worked at her father's desk, a big Arts and Crafts piece of furniture. We seemed to be huddled together at times. At some vague hour she would cry, 'Food!' and make scrambled eggs. Her dining table was a board laid over her bath. She would fling a check tablecloth over it and laugh when I couldn't get my feet under it.

I was frequently at Little Easton Rectory at this time, and so could gossip about Thaxted. Canon John Barnett

was himself a considerable musician and Imogen was amused by the fragmentary things I had learned from him. Or had especially liked. Reynaldo Hahn's songs for instance. Hahn was a pupil of Massenet and Proust's first lover, and the part-origin of the composer Vinteuil whose 'little phrase' haunts *Remembrance of Things Past*. The other was Henri Duparc.

But John Barnett's enormous library of 78s also introduced me to Gustav Holst's music and that of his contemporaries Vaughan Williams, Herbert Howells, Arnold Bax, Frank Bridge and John Ireland, as well as Bach and Mozart. Each record would be denuded of its sleeve, lightly dusted with a velvet pad and placed on the turntable. Or the Canon would play for hours at the Steinway piano, cigarette ash – Balkan Sobranie – tumbling down his cassock. A huge, untidy, somewhat unwashed figure with stained teeth and a beautiful speaking voice, a widower with a love now of young men, he did little new in the parish. Once after a walk to Little Easton village itself he asked, 'What is it like down there?' He trundled about the Essex landscape giving inspired music talks to the Workers' Educational Association. Now and then we went to Thaxted where Conrad Noel's banners floated above the arches in what I always thought of as Gustav Holst's church.

In 1912 the Countess of Warwick, née Frances Maynard and heir to vast Essex acres, became a socialist, eventually filling her farmhouses and cottages with

musicians, actors and writers. Each of these buildings had a handprint with a coronet over it in the plaster – *manus*-Maynard. Solomon the pianist, Philip Guedalla the biographer and H. G. Wells, amongst the distinguished tenants, had cycled the lanes. John Barnett's services were a kind of slovenly holiness, himself frequently in his pyjamas under his robes . . . But on Good Friday his Steinway would be hauled across the road by the farm labourers and placed on the chancel step where, during the Three Hours, people would come from near and far to listen to Bach. I took the poet James Turner there and he wrote:

> Out of the West, out of the dying sun
> The trumpet sounds.
> Angels of flashing light be over me,
> Thy garments like a gauze of setting sun.
> Closing the epoch of a dying age.
> The trumpet sounds.
> Over the scandalous Hill, distantly proclaiming
> A whisperer's promise
> Of the perfect oblation.

Gustav Holst, who had died in 1934, was still a potent force in this Essex countryside. Walking and cycling I could 'hear' him. He too had discovered it whilst tramping through a five days' holiday during the winter of 1913. Most of all Thaxted, where he had put

up for the night at the Enterprise in Town Street. In 1914 he rented a cottage from the Essex dialect writer S. L. Bensusan, whose nephew John Bensusan-Butt was a friend of mine. Imogen tells what happened next:

> The cottage dated from 1614; it had a thatched roof, and open fireplaces, and a wonderful view across meadows and willow trees to the church spire in the distance. In the fields beyond our garden we could watch the farmer sowing the seed broadcast . . . Here in this quietness, my father, who had been rejected by the recruiting authorities as unfit for war service, was able to work at *The Planets*.

The Holsts lived in this house, Monk Street Cottage, until 1917, then they rented The Steps in the centre of Thaxted for the next eight years. One evening, working with Imogen, I happened to mention my weekend at Little Easton Rectory and she said, 'That was our part of the country!'

In her 1952 diary, after she had taken neat copies of her work on *Gloriana* round to Ben, who had been in bed all day with a cold, the two of them settled for a drink – Drambuie, a favourite, for her and rum for him – during the course of which they discussed the future:

> He said couldn't I possibly arrange my work to stay here next year, and where did I really want to live.

So I told him Thaxted was the only place but that I was too emotionally involved to live there just yet. And he said could I teach in London & live here the rest of the week & I said I could *probably* manage another year as freelance: – but that I'd have to learn to put my feet on the ground because I'd never been so happy for 3 months on end before. [. . .] He said, 'You've helped with *Gloriana* in more ways than you know.'

My closest relationship with Imogen was when Ben and Peter were far away in Bali and she more or less took charge of the 1956 Festival. I wasn't aware of this at the time but I do remember an exultancy about her which was catching. Trailing up the stairs to her flat she called out, 'The Festival is everything – *everything* – dear, isn't it?' And I felt a warning. But she set me to work on the Programme Book and, given a free hand with it, I was also aware of a rise in my status, or rather the realisation that she had, mercifully for him, stolen me from Stephen Reiss. Could Kurt Hutton take the pictures? Could John Nash do the line drawings? Might I discuss the printing with Benham's of Colchester? Imogen's own freedom was catching. It was when the cats are away the mice do play but also that change of the world thing which I now and then saw in her face, and which I later thought of as the breakthrough joy of early socialism – the expression of it which William

Morris and the nineteenth-century Fabians possessed. There must be a portrait of Schubert but not that lozenge-shaped pair of spectacles. Imogen always knew where things were. She knew where he wasn't wearing them. 'He was *beautiful.*' So we wrote to Munich for a drawing which entirely revised one's concept of the young composer. I have kept the print to this day.

Imogen's triumph at this moment was to reinstate her father's one-act chamber opera *Sāvitri.* A previous attempt to stage it had been postponed and *Albert Herring* substituted in its place. The decision to make this change came after Imogen had to leave halfway through an Executive Committee meeting because of a rehearsal in Ipswich. The reason was its cost. It was to have been part of a double-bill which included *The Soldier's Tale.* Now it would share the evening with her new presentation of John Blow's *Venus and Adonis.* There was a fairly Wagnerian Gustav Holst in *Sāvitri,* and a thrilling Imogen in *Venus and Adonis.* Her genius was to work through old texts like the Aldeburgh wind, refreshingly if mercilessly. In this instance from a 1682 manuscript in the British Museum. She ended the Children's Concert in the church with her father's hymn 'Turn back O man, forswear thy foolish ways' which he had composed for Whitsun at Thaxted in the midst of the First World War's appalling losses on the Western Front. Imo conducted 230 Suffolk children singing it on a summer's afternoon at Aldeburgh. Both she and

Ben had a kind of direct line to children. They would arrive with a mixture of resentfulness and bravado, and would leave quite changed.

Sāvitri – the 1956 performance – revealed both Imogen's and her father's India. Gustav had been obsessed by Indian culture and Imo had spent two months studying Indian music at Tagore's university in 1950–51 just before leaving Dartington and arriving in Aldeburgh. She wanted to collect Indian folk songs and she set about it much as her father's generation had done before 1914. The brilliant singing teacher Pandit Onkaamda Thakar gave her a compacted study of an endless subject. Only an Imo could grasp what she did in so short a time. It was a two-way teaching. She learned; the Indians learned. They sang Britten and Bach, she found that their style of singing took a bit of getting used to – their habit of what we would call 'scooping sounds' distressing to Western ears until one has learned to accept it as 'inevitable'.

And now she and I, and E. M. Forster, were walking from Ben's house to the Jubilee Hall to hear *Sāvitri*. At last. Aldeburgh itself was like a great song. Or was this because I had stopped being so anxious and was just looking and listening? Imogen sat between us at the front. The opera marked a high point in the performance of Gustav's work. Her dutifulness towards him came second to her knowing its importance. She was still and absorbed.

Holst had written his own libretto from a Sanskrit story in the *Mahabharata*. Satyavan, a woodman, comes home one evening to his wife Sāvitri, and hears a stranger moving in the forest. He raises his axe but the strength goes from his arms; the stranger is Death. Instead of cursing the intruder Sāvitri welcomes him. Death is so impressed by Sāvitri that he promises her anything she desires for herself, but she must ask nothing for her husband. She then makes a passionate appeal for life in all its fullness. But what is life without him? Death sees that he has been defeated and vanishes. For even Death is an illusion. Satyavan wakes with his wife's arms around him. She tells him that a Holy One has visited them both – and blessed them.

Arda Mandikian sang Sāvitri and Peter Pears Satyavan. Thomas Hemsley sang Death.

One of those ridiculous but ineradicable things occurred as the three of us were leaving. Forster's cap had fallen to the floor. When I rescued it I saw that it was covered with dust so I banged it on my knee. Instead of thanking me he was cross. Cross – or worse – too when on returning to Ben's house in Crabbe Street he saw a big police notice fixed to the wall – to stop parking. These trifles seemed to have obliterated all that we had seen and heard. He was upset. I held his hand for a moment before he disappeared. But when we met for dinner at the Wentworth Hotel a little later he was happy again. Imogen was pushing the boat out, to use a

suitable banality, and had ordered one of those snowy
tables in the restaurant which I had only seen through
the window, and the manager Lyn Pritt himself had
seated us. I can't recall what we talked about, only the
moment, the noise of the sea, the privilege of it all. Imo
loved a drink, or three drinks, so I expect there was
wine. Maybe that which I had helped Lyn to cork and
label in the Wentworth's cellar.

A year or two before, Forster had published *The Hill
of Devi*, a collection of letters, including those from
India where he was tutor to a Raja:

Let me describe myself. Shoes – I had to take them
off when the Palace was reached, so they don't
count. My legs were clad in jodhpurs made of
white muslin. Hanging outside there was this
youthful sirdar's white shirt, but it was concealed
by a waistcoat the colours of a Neapolitan ice –
red, white and green, and this was almost concealed
by my chief garment, a magnificent coat of claret-
coloured silk, trimmed with gold. I have found out
to whom this belonged. It came to below my knees
and fitted round my wrists closely and very well,
and closely to my body. Cocked rakishly over one
ear was a Maratha Turban of scarlet and gold –
not to be confused with the ordinary turban; it is
a made affair, more like a cocked hat. Nor was this
all. I carried in my left hand a scarf of orange-

coloured silk with gold ends, and before the evening ended a mark like a loaf of bread was stamped on my forehead in crimson, meaning that I was of the sect of Shiva.

Forster's clothes were a miracle of drabness, I used to wonder where one could buy them. They were so careful in having nothing to say. But his talk! Imo's talk. How can I recall her sentences but not his? The lopsidedness of life.

Imogen's flat looked out on the High Street and towards the sea. The floor was covered with fresh coconut matting and a design for Honegger's *King David* by Kokoschka hung on the wall. Seagulls would skirmish on the windowsills. Neat copy fluttered all over everything. Once when I went to Dartington they let me have her room which was uncannily similar to the Aldeburgh flat. There they spoke of her with love-struck awe, and with still a kind of mourning at her going. And I too was made aware of the wealth and comfort which she abandoned in 1951 for what at first was a virtual homelessness and a suitcase. Also a desert from a throne – not that this would have occurred to her. When we met in 1955 these losses had been sensibly replaced by her knowing the total dependency which Britten, the greatest English composer of the twentieth century, had on her. There was no one else. They were about the same age. They shared a similar

music culture and a similar drive, and in some ways they were equals.

As the Festival spread through the town, engulfing the Jubilee Hall, the Parish Church, the Baptist Chapel, the Moot Hall, the hotels and boarding houses, the beach, the very air, there were rumbles. But Imogen had only to walk down the High Street, her eyes fixed on no one or anything, than a kind of armistice ensued. She would 'look straight past you' but people understood. Should someone, not knowing the drill, bring her to a halt she might give them a full minute of her time. But no one for a minute thought that she was stuck up. Miss Holst had better things to do than gossip. She had no idea that she walked blindly through something approaching adoration, nor would it have pleased her to know it.

I would tell her about the circle at the far end of the town, the artists Juliet Laden and Peggy Somerville, and the writers who were often with me, and Imogen would say, 'But don't they like our Festival? – some do not.' And I would say, 'They don't know it is ours.' Which was true if strange. There was another Aldeburgh, another Suffolk. Some thought that the Festival was wearing me out and some that the shoemaker should stick to his last and just write. Their concern made me feel pleasantly hard done by. But the contrasting venues of Crag House and Brudenell House created a drama in my life, whilst the ancient basic Aldeburgh

of the fishermen enthralled me, it being so remote. I remember attempting to emulate Imogen's indifference to accommodation, but this was impossible. And to both her and Christine Nash's incomprehension I spent a lot of time making 'a nest'. Their word.

Sometimes Ben would drop me off after a Festival meeting in his Rolls, and all at once I would feel troubled and lonely. Unsure of myself and 'far from home'. Although the question was, 'Where was home?' And where should I be going? And, maybe, who with? When Imogen knocked on my door with a Cragg Sisters' cake, it would be 'Very nice, dear.' But not looking around. All anyone needed was a chair, a table and a bed. Unless one was Benjamin Britten when a Miss Hudson was essential. I don't think anyone 'did' for Imogen. She adored food and drink but was no cook. I was openly hungry half the time like a dog.

Imogen said in her diary:

When I went down the stairs Ben was putting his shoes on to walk uphill with me – he said wouldn't I stay but I said no and then when he got to the door he looked so depressed that I said yes. So we had a drink . . . so we drank to wealth and he said 'Good old Peter Grimes' and we laughed a lot and he said he hoped I wouldn't think that life at Aldeburgh was *always* like this so I assured him it was nothing after life at Dartington.

But it was. On this occasion, 'Miss Hudson had cooked a superb meal and we both felt better.'

Rehearsing on the Crag Path in the evening I would fetch fish and chips and we would sit on the wall in a line to eat them. But the real feed was in Juliet's limitless kitchen at Brudenell House. Or a similar meal at Peggy Somerville's limited table.

Imogen died early on a March morning in 1984. Might she have a sip of water – like a bird? After which 'her head drooped gently sideways . . . and she slipped away'. I watched her funeral procession to where Ben lay in Aldeburgh churchyard on local television. A handful of friends sang the five-part *Sanctus* by Clemens non Papa, a canon she had taught them, at her open grave. The last time I saw it, pointed sycamore leaves had covered it.

On 29 September 1952, her first day as an Aldeburgh inhabitant, she wrote in her diary:

Ben asked me in after a choir practice of *Timon of Athens*. We were talking about old age and he said that nothing could be done about it, and that he had a very strong feeling that people died at the right moment, and that the greatness of a person included the time when he was born and the time he endured, but that this was difficult to understand.

On Bach

He was spared the nineteenth-century craving for originality at any price.

It would be fairly safe to guess that the first tune he ever heard was a hymn tune.

In the prolonged hush before the expected 'resurrection of the dead' the harmonies move through remote regions that had never before been explored. And in the final 'grant us thy peace', the piercing notes of the trumpets mount higher and higher to their climax of gratitude.

On Editing Other People's Music

This talk is concerned with the editor's need for second thoughts; with the sight-reader's struggles to disregard most of what is on the printed page; with the composer's exasperation at having to fight against the publisher's house rules, with the learner's lack of definite instruction, the listener's damaging preference for what he is used to, and with the danger of still believing everything that one has ever been taught.

On Folk Music

Looking through the early volumes of the *Journal of the Folk-Song Society* we can almost hear the 'twiddles and bleating ornaments' of Mr Joseph Taylor, carpenter; and the broad, even notes of Mr George Gouldthorpe, lime-burner, who 'gave his tunes in all possible gauntness and barenness'; and the 'pattering, bubbling, jerky, restless and briskly energetic effects' of Mr George Wray, brickyard-worker and ship's cook, who had a grand memory at the age of eighty and sang his innumerable verses with a jaunty contentment.

Those who live in the North are used to keeping out the cold by singing with half-closed vowel sounds to prevent the gale-force wind from giving them toothache, and by dancing quick rhythms with all their energy.

On Her Father

Over tea in front of a blazing fire, he [Britten] suddenly said, 'Did your father get terribly depressed?' And then before I knew where I was I told him how I'd neglected G [Gustav] during the last 2 years of his life, being ambitious about jobs instead of ruling bar-lines for him, and how it was one more reason why it was lovely to be doing

bar-lines in *Gloriana*. Ben said he'd been quite sure that he'd been responsible for his mother's death & it had taken ages to realise that he hadn't been.

On Leaving Dartington for Aldeburgh

Ben will realise that when one is always teaching amateurs and future professionals who are still immature, one needs constantly to be criticised on one's own music by someone who one knows is a better musician than oneself. Now in South Devon, we had so many blessings but we hadn't many musicians better than me at that time . . . I thought I mustn't get into the habit of this. I remember walking round the garden in early spring and thinking, 'Now, you could live here for the rest of your life.' It seemed a kind of heaven on earth, and then thinking, 'No, because you are a musician, and you have got to go on teaching and got to go on having really strict criticism.'

In 1952 I came to live in Aldeburgh to help with what Britten described as 'an infinity of things great and small'.

On Noye's Fludde

The first plans were discussed on a long walk over
the marshes with the rain streaming down our
necks; not long afterwards we were buying china
mugs from Mrs Beech in the High Street, to
be slung up for the newly invented percussion
instrument. I remember the concentration on
Britten's face as he tapped each mug with a
wooden spoon.

On the Advantages of Being Seventy

I must make room to include the blessing of not
having to go on buying new clothes when the old
ones are not only tougher but are also much more
beautiful. For special occasions in the Directors'
Box at the Maltings I'm still wearing the wool-
embroidered evening jacket I bought for £5 in
South Kensington in 1928.

9 Staverton – What Happened? – What Is Happening?

CAPTION: John Nash: *Staverton Thicks*

One April morning in 1956 I made one of my planless walks from Slaughden towards Orford and with the usual elated feeling. There would be a wonder midway although I knew nothing of its existence. All I experienced at this moment was a tossing about of freedom. The sea was glorious and near at hand, the gulls screamed and the air was intoxicating. At Slaughden the Alde turned into the Ore, and the Aldeburgh Marshes became the Sudbourne Marshes. On the left were the Lantern and King's Marshes. Orford Castle was the obvious destination but like a boy leaving the biggest sweet in the bag until last, I turned right towards Butley. Somebody had told me that Chillesford Church tower was pink because it contained lots of coraline crag. But what drew me would be the stunted oaks and the limited nature of things. And yet at the same time the grandeur of things, for Victorian aristocrats had shot over these acres. So I saw Hansel and Gretel Lodge, and dark entrances to country houses, and signposts to Hollesley where Brendan Behan would be a Borstal Boy. This walk would become a preface to a guidebook as yet unwritten. The poor soil of the Suffolk sandlings had made for skimpy farming

but had provided the next best thing to Scotland for shoots.

Just below it there existed something else. Butley loomed large on my 'Geographical' two-miles-to-the-inch map. A rivulet wriggled in its direction. And so I came to the Thicks a little way on the right of the Woodbridge road. It would play a large part in my imagination. I took all my friends there, the poet James Turner, John Nash, the Garretts, Richard Mabey. 'Yes,' said Benjamin Britten, 'I know it well.' John Nash had told me that when he was painting he 'liked to have a dead tree in the landscape'. Except that Staverton Thicks was not dead, only perpetually dying. And thus everlastingly alive. Although with no apparent struggle. It showed its great age and exposed its ageing, and one flinched from such candour. But why had no one cleared it and replanted it? What had happened? What was happening?

An early friend of John Nash's youthful days was Sidney Schiff, the translator of Proust. Schiff had taken over as translator when Charles Scott Moncrieff died. John Nash gave me the first volume, *Time Regained*, which Schiff had given him. In it Schiff, who wrote under the name of Stephen Hudson, had put, 'My dear John, I want you to have this book. Begin by reading from p. 210 to p. 274. If that means so much to you as I hope, begin at the beginning and read it *slowly* to the end. 30th March '32.'

These sixty or so pages describe a soliloquy on the artist–writer's life when, arriving late for a concert, he is put into the library until the first work is ended. His memory wanders back to the celebrated memory-providing madeleine and, although he is in Paris, to the Normandy coast, and takes in the decision to be either painter or writer. I had just read Sidney Schiff's instructions. Fragments of the soliloquy in the Paris library fluttered through my head as I walked towards Orford and penetrated the strange wood. Passages such as 'the large bow-windows wide open to the sun slowly setting on the sea with its wandering ships, I had only to step across the window-frame, hardly higher than my ankle, to be with Albertine and her friends who were walking on the sea-wall' made me think of Juliet Laden and Peggy Somerville softly drawing in pastel the young people below, and how perfect it would be this very evening to be at Brudenell House telling them about my walk. I too was attempting to concentrate my mind on a compelling image, a cloud, a triangle, a belfry, a flower, a pebble. I wondered if I should make the lovers in my half-written novel walk this way. And then, thinking of Denis Garrett and his botanic company, I was startled when Proust includes him in these recommended pages – when the narrator says that his sorrows and joys

had been forming a reserve like albumen in the ovule of a plant. It is from this that the plant

draws its nourishment in order to transform itself
into seed at a time when one does not yet know
what the embryo of the plant is developing, though
chemical phenomena and secret but very active
respirations are taking place in it. Thus my life had
been lived in constant contact with the elements
which would bring about its ripening . . .

The writer envies the painter; he would like to make
sketches and notes and, if he does so, he is lost . . .

John Nash sketched through a grid of lines and
dotted in here and there 'late afternoon', 'browning
grey', 'still water', as reminders.

According to his youthful armour-bearer it was
among the young oaks of Staverton that St Edmund
was murdered by the Danes, tied naked to one of the
trees and made a target for arrows. This armour-bearer
lived, like the trees, to be very old and thus he was able
to tell this execution to Athelstan, who told it to
Dunstan, who told it to his friend Abbo of Fleury, who
sensibly wrote it down.

The Thicks was also the scene of a Tudor picnic,
when Charles Brandon, Duke of Suffolk, and his wife,
Henry VIII's sister, spread linen in its shade, drank
wine, sang songs and ate – what? This story delighted
me as a kind of alfresco masque; when I imagined a
pretty site a mile or so from the shield-bedecked
Augustinian Priory, and some spontaneous desire to

make merry out of doors. But then I looked up the Duke – and what a monster! But a good-looking monster, one of the 'new men' of the Reformation who had gone from strength to strength without losing his head. I see him lying full length on the then thick summer grass, the oaks above as young as he is, and by his side his wife Mary who was once Queen of France. Henry was furious when they married in Paris without his permission, but calmed down when her enormous dowry for the first husband was returned in instalments. In Suffolk they called her 'the French queen', not the Duchess. She would have been buried in St Edmundsbury Abbey had not her brother pulled it down. But she can be found in a corner of St Mary's Church near by, the woman who ate – what? – in Staverton Thicks.

Hugh Farmer, into whose little wood I stole so long ago, himself describes it in a Festival Programme Book. He lived there and his account of it is incomparable. He tells of his life there in *A Cottage in the Forest.* But it has never been the adjunct of a great house.

 The trees consist chiefly of oaks of every conceivable shape, although none is of very great height, and of an age estimated at between seven and eight centuries. Many are stag-headed because, until its abolition a century and a half ago, there was a right for local people to top and lop the trees for fuel.

Many of them are hollow and hollies and elder
seeds brought by birds have rooted and grown up
from the crowns, so that sometimes a tree grows
out of a tree . . . There is a tradition that this is a
Druidic grove and at night, when the owls are
crying and the gaunt arms of the ancient trees
seem outstretched to clutch, this is an eerie place
. . . A remnant of primeval forest. A very ancient
plantation to provide the Priory with fuel and
timber for building . . . What does it matter?
Staverton Park is probably the oldest living
survival in East Anglia, a strange place, history
and tradition apart, with a character all its own.
On a still midsummer night when the nightjars
churn, and the roding woodcock croak overhead,
in deep winter when the snow under the hollies
is crimsoned by the berries dropped by ravenous
birds, or at autumn dusk when the mist rises
wraithlike from the stream and the rusty wailing
of the stone curlew sounds across the trees, it has
a magical beauty.

I thought of Saxon and Viking princelings. The
Thicks has a partly thwarted Phoenix ambition, to die
and yet live. But the thing is itself a form of dying. The
long-settled condition of these botanic infirmaries, for
they exist here and there where a tidying hand has not
invaded them, are a requiem. The rich deep mould of

their floor, the feeble barriers of guelder and hazel which let through the north-coast wind, the close canopy of undernourished branches which check full leafage, all these 'disadvantages' are time-protracting. For an oak, a holly, the chief enemies of existence are parasitic fungi, canker caused by sunburn, frost aphis of one kind or another – and lightning. They say that it strikes an oak more than any other tree. Once, cycling from Framlingham on a storm-black afternoon, I saw lightning fire an old oak in a park. It blazed up only a few yards away with a mighty crackle of dead and living wood.

Most of the Staverton oaks are so near death that they seem to be nothing more than gnarled drums for the gales to beat. Yet so tenacious is their hold on life that the twigs sprouting from them are still April green. And come August 'Lammas' growth will hide some shrivelled bole.

The mood of the Thicks depends on that of its visitor. I found it a contemplative, loving silence. Little or no birdsong. An absence of that rustling busyness created by small unseen animals. A carpet-soft humus deadened my every step. So soft was it that sparse forest flowers – sanicle shoots, wild strawberry, speedwell – can be trodden into it without injury. A sequence of glades has its own special senescence. It is like walking through an ill-lit gallery of sculpted last days. Except that here there is an endless putting off of last days.

As Staverton means a staked enclosure, what was it that was enclosed? And why were its 'thicks' left to degenerate when the remainder of the forest was not allowed to? Why was it allowed to do what it liked? Yet it feels neither cursed nor abandoned. It is like a woodland mortuary, yet not tragic. Its enigma lies in some destiny which we now know nothing of. For some reason it was intentionally untouched – and staved in. It is grotesque, part a wood from Gormenghast, part a lecture on death, part a ruin of miscegenation. Holly props up oak; ivy alone flourishes. Wild creatures for the most part avoid it. It is botany as departure – yet neither root nor leaf ever goes.

10 At 36 Crag Path

When the Allied armies reached Belsen and the other concentration camps such was the terrible bureaucracy of death that all the other horrors of war paled before it. Not only soldiers and statesmen, religious leaders and welfare workers felt it their duty to see Belsen, but poets, artists, musicians and philosophers too. The most distinctive memory I have of the two Jewish friends I had in Aldeburgh in the Fifties was their silence on the Holocaust. Leon Laden, a Dutch Jew, had married the artist Juliet Perkins and had come to live in Brudenell House, and Kurt Hutton and his wife Gretl had come to live at 36 Crag Path. Leon said that he was writing a thriller. He sat at his desk all day. A dozen or so HB pencils of various lengths were arranged in meticulous order like organ pipes. Our wonder was what sentences had worn them down, for not a word emerged from the study. His wife Juliet and her friend Peggy Somerville, who had been together at the Royal Academy School before the war, did pastels. Kurt Hutton had come to Aldeburgh in the late Forties, partly for his health, partly to photograph it for *Picture Post*. The Ladens heated Brudenell House by leaving the gas stove on all the time, and the Huttons heated 36 Crag Path by

leaving a big paraffin stove at the top of the stairs on
all the time. Such decadence amazed Aldeburgh. It was
a little flicker of Europeanism. Far away, long ago, a
front door was being opened in Vienna, in Berlin. No
sooner had my muse Christine Nash sat in the flat which
Imogen Holst found me, than she went out and bought
me an Aladdin stove and gallons of paraffin. I used it
meanly, having been brought up on the advice, 'Put
another jersey on.' Both Brudenell House and 36 Crag
Path became 'safe houses' from the rigours of the Alde-
burgh Festival. In them my disparate Jews maintained
a matching silence on the enormity which had swept
them into Suffolk.

I too found the matchless crime of the Holocaust so
wicked, so incredible, that I had to reduce it, if this
could ever be the word, to a single illustration of its
evil. At a photographic exhibition in London I saw a
group of gypsy lads standing in the snow on Christmas
Eve, taking their turn to be gassed, whilst candles shone
in the window of a guard's house. They were naked,
beautiful, waiting. It could have been this picture which
gave me the entrée to Kurt Hutton's black-and-white
photo-journalism. It belongs to the classic period of the
camera which produced such artists as Henri Cartier-
Bresson and André Breton, dark-room Modernists
whose images define the inter-war years, often beyond
words. Kurt Hutton began to use a Leica as early as
1927 when he had established a studio in Berlin, first

working with a conventional camera and a quarter-plate reflex. But the Leica cut the umbilical cord which bound him to static equipment. It made him think and see differently. He described this transition a few months before he came to Aldeburgh.

Why do I photograph the way I do? Because it is the only way to achieve what appeals to me most in photography . . . There is, of course, photography making no claim to naturalness which may be of high artistic value, but that is something altogether different. I am talking about simple straightforward photography. Its results should strike you as being alive. By this I mean a photograph should suggest that behind the face there is a thinking and feeling human being. The posed photograph so often shows a blank mask. The subject is aware of nothing but the camera and is as paralysed by it as a rabbit by the snake . . . But it is not much use having the quickness and all the resources to steal pictures if you do not know what pictures to steal . . . People in themselves have got to mean something to the photographer . . .

I have no idea what I meant to Kurt and Gretl Hutton. Imogen Holst introduced us. She was the only person who pronounced 'Kurt' correctly. We all said 'Kurt' to rhyme with 'shirt'. Historically their partnership, Kurt

with his eye, Gretl in the darkroom, would produce a visual record of the Aldeburgh Festival from its beginning without parallel. And also of 'my East Anglia' as I led them to the most unlikely spots, Little Gidding, Newmarket, Flatford Mill, and to Sir Cedric Morris and John Nash, looking up from their gardens. Gretl drove. Off we went to steal pictures, with my accompanying words, not captions. I would now and then catch Kurt biting back his amusement. I was the same age as his son Peter. I never knew until many years later that he had served in the Hitler Youth and that Kurt had 'J' for 'Jew' on his passport. Or that Gretl had been a Viennese dress designer.

In fact Kurt Hutton was really Kurt Hübschmann, a cavalry officer who had won an Iron Cross, Second Class, at Verdun, who had briefly studied Law at Oxford, and whose father had been a Professor of Comparative Philology.

Peter Hutton and I began a lifelong friendship on the Crag Path. His son Sebastian is my godson. I remember carrying him in my arms around Durham Cathedral and pausing at St Cuthbert's tomb with its stripped feeling. Not far away the Weir – water – roared down its rockface. No Leica to catch this Hutton moment. Letters held us together when Peter and his family settled in New South Wales . . . In Aldeburgh, usually in order to make an early start on one of our (my) photo-journalist outings, I slept in a front bedroom and

would get up at six just to look out of the window. Sometimes the enigmatic old man humping a sack who used to pass at Thorpeness would appear. Or fishermen to start the day's idleness. Well-dressed women walked their dogs or just themselves in the keen morning air, ladies with time on their hands and little balconies. Fidelity Cranbrook called them 'the abandonees'. Might not their husbands have died in the war? 'No, dear.' They came into their own at Festival time, selling programmes, showing people to their seats. Their children appeared from distant public schools during the holidays. What on earth do they do all day? 'Nothing, dear.' Like the fishermen. Unlike Kurt, who swam until he was crimson, then strolled around with his camera, carefully alone, helplessly European, helplessly active. Never belonging. Like Leon Laden, only differently.

Refugees were too busy extricating themselves from the disaster to do much assimilating. My favourite wartime poet was Sidney Keyes, killed in the Western Desert. He wrote:

The ones who took to garrets and consumption
In foreign cities, found a deeper dungeon
Than any Dachau. Free but still confined
The human lack of pity split their mind.

Ben revealed his Europeanism all the time. Whilst I, who had been nowhere and whose friendship with two

Jewish doctors in particular had merely shown up my provincialism, had to fight my way out of my limitations. It would be the Huttons, and later Erwin and Sophie Stein, she with her tumbling laughter and open-armed approach, who would dissolve my primness. I would walk into Ben's house, which seemed to be always full of people, and hear its tensions being swept away by Sophie's unrestricted happiness.

Now and then Kurt and Gretl would frighten me with a bogeyman named Simon Guttmann. Would they, could they, allow an innocent such as me to meet Simon Guttmann? Unbeknown to me our joint photo-journalism was passing through his hands. Was he their agent? *'Agent!'* Their eyes would meet. But they were, I soon realised, genuinely alarmed by what Guttmann would think when he received our joint efforts. My words, Kurt's pictures. My subjects – Little Gidding, the Yearling Sales at Newmarket, a Woodbridge auction, the Field Study Centre at Flatford Mill, Sir Cedric Morris's art school at Hadleigh. Kurt's account of Guttmann verged on the shocking . . . He made him sound like Quilp crossed with Goebbels.

One day, with exaggerated concern for my safety, they sent me to Guttmann. My shield would be that other than their comic libels I could know nothing about him, not being a photographer. They saw me off with pantomime prayers. Imogen was on the train, music paper spread over her knees. She was not to be

spoken to. A little smile then the bent head. Somewhere off Regent Street, maybe, up two flights of bare stairs, there he was, fixed in a hard chair. They said that when this had to become a wheelchair it also became a chariot of fire. Aldeburgh seemed continents away.

'Sir, sir.'

He was slight, intense. And although I didn't know it, the master of European photo-journalism. He was in his sixties. He held out his hand for copy but all I had were suggestions. He listened to them irritably. He did not ask after Kurt. He did not stand up when I left what seemed like days afterwards, but took my hand gently.

'What should I tell Kurt, Mr Guttmann?'

'Tell him that you met me.'

And so, vacant and yet somehow fulfilled, it was back to Liverpool Street. I kept thinking of the nervous studies of Ben and Peter and of myself when I wasn't looking, and of likenesses which I would never quite catch, those of friends who had managed to escape the death camps.

Guttmann himself had crossed the Spanish border on all fours. When he got to London he worked for Richard Crossman in Holborn, producing Free French magazines. He was born in Vienna in 1891. In his late teens he became a member of the 'Neue Club', a café group which read poetry and sang in Berlin. Guttmann brought the artists of Die Brücke to the Neue Club. When the Kaiser's war was declared Guttmann

pretended that he was suffering from TB in order to avoid being called up and went to live in Switzerland. In 1917, with the world order breaking up, he moved to Zurich where he met Hugo Ball and took part (auctioning a doll) in the first Dada Cabaret at the Club Voltaire. After the war he met Mayakovsky in Moscow. In 1928 Guttmann found his apex, Dephot, a firm which supplied pictures and stories for the picture-paper industry in Germany. He also found a young photographer named Hübschmann – Kurt Hutton. Dephot was the first agency to supply stories and not just captions to pictures.

I saw Guttmann saying to himself, 'So this is what the great Kurt Hutton is doing in the country – this young man's photo-tales. Farming! George Herbert! Little Gidding! Horses!' But Guttmann himself had been guilty of wild undertakings. When Stefan Lorent founded and edited *Picture Post* in 1938 Kurt, a major contributor of the photo-essay, had said, 'You will find Guttmann extremely difficult.' Later it would be Guttmann who taught Tom Hopkinson, Lorent's successor, this journalistic art. *Picture Post* now makes amazing reading–viewing.

I told Guttmann that Kurt and I would like to make a photo-essay about pike-fishing in the River Stour. What did he think? He looked confused. Many years later I read his obituary in *The Times* and saw that I had got off easy:

Grace Robertson, photo-journalist of the 50s, describes Guttmann's method of teaching. 'He threw my enlargements – fruit of long hours in the darkroom – on the floor and *stamped* on them. His eyes flashed with anger behind his spectacles as he muttered, "Kurt Hutton would *never* have taken pictures like these."'

Simon Guttmann died aged ninety-nine in 1990, the last of the Expressionists. He, Kurt and Gretl Hutton, Leon Laden and the shy woman from Summerhill School at Leiston carried with them the terror of their time. It never quite vanished. I continue to pore over Kurt's Aldeburgh which for two years was my Aldeburgh. I suspect that Guttmann was unable to 'see' it. When I remember Simon Guttmann I also remember Rilke.

> Look, the last hamlet of words, and, higher,
> (but still how small!) yet one remaining
> farmstead of feeling: d'you see it?

Brudenell House, where Leon and Juliet lived, was gaunt and pebble-dashed outside and 'Charleston' inside. Juliet had painted the woodwork green, cobalt, and dull gold. She kept it warm by leaving the lit gas stove on more or less permanently. On a fine day she and Peggy Somerville sat in the open window drawing

swimmers and sunbathers, passing children, the sea and the boats. And there were lovely intimate Bonnard-ish interiors of the breakfast table and ourselves reading in wicker chairs. Now and then Leon would leave his life for our life. We would go to the pub and he would tell the landlord, 'Gif me some beer.'

'No, no, Leon, he is our host. You must say, "Good evening".'

And I would wonder what orders Leon had heard when the Nazis overran Holland. Juliet fed us on bolognese, huge panfuls of it. As neither Peggy Somerville nor I could drive, she took us around in a three-wheeled car from which the floor had vanished. We would watch the road flying under our feet. Peggy lived with her blind mother at Westleton.

'Tell me what you saw today. Tell me where you are going tomorrow. Will you really read to me? Oh, darling!'

I chopped up wood for the fire. Should I mention Juliet's husband Peggy would look troubled. Nothing was said. But then the silence of Leon and our silence about him was hugely eloquent. No need for words when it came to the unspeakable Holocaust.

'Marry Peggy,' said Juliet.

I could not tell her why this was impossible, or that Peggy showed no sign of wanting to marry anyone. There were other silences then. Stephen Reiss would appreciate and understand her work and after her death

make it widely known. Juliet would divorce Leon and move impulsively across Suffolk, leaving each house more colourful and yet with an added remoteness. None of these friends came to the Festival. It was as though it wasn't there. When I arrived in the evening for the bolognese and to see the new pastels, and have a warm by the gas stove, I would chat about it. I told Juliet that the setting by her uncle Martin (Martin Shaw) of Gerard Manley Hopkins's poem 'God's Grandeur' had been sung by Peter Pears at the very first concert and she would give the little smile with which she held the world away from her. But we never ceased to do the things which belonged to her beloved realm of colour. One was going to the fair. Juliet, Peggy and I would drown in its blaring music and spend a fortune on the roundabout and swings. It was held on the waste ground which led to Slaughden. They wore stiff cotton dresses with dirndl waists and rope sandals, and had flying hair. We shouted like children.

I had met Martin Shaw before I came to Aldeburgh. The Shaws were Southwold people. Martin and Gordon Craig had sat on the beach there before the First World War planning revolutionary new ways to simplify theatre production. They were to be English Stanislavskys. Martin himself was tragically dramatic. A 'port-wine' birthmark exactly halved his face which was handsome and aquiline. He stood whenever he could in white-side profile. We were curious to know how far

down it went. He, Percy Dearmer and Ralph Vaughan Williams had created – 'edited' would hardly do – *The Oxford Book of Carols*. All the Aldeburgh composers and singers adored this compilation and I often felt that Imogen inherited some of her joy from it.

But Juliet's sister Jane was angry with Martin Shaw's 'churchiness'. 'He could have been an international stage designer and composer.' Aldeburgh was where Jane Garrett and I began a lifelong friendship. Just as she regretted Uncle Martin's church music, so she regretted my Festival work. 'You should be *writing*.' But I was – all the time. 'What are they making you do now?' She would say that her marriage to Denis Garrett was like the peace between the Montagues and Capulets, the 'two houses which had been at varience with each other' in their case being Perkins's Diesel Engines and Garrett's Leiston Works; two firms which had transformed agriculture. Denis Garrett was literally at the root of the matter. Aldeburgh for them was marine plants, not music.

They met Kurt of course. They spoke a common scholarly, radical language and they were not in any way provincial. And certainly not completely localised like me. Kurt and Gretl were amused by my constant talk of Suffolk. They had come to Aldeburgh for the climate and had never so much as thought of its hinterland. The Garretts lived in Cambridge and although we spent weeks exploring the Fens, Denis's heart and soul were on the few miles of beach between Leiston and

Orford. Jane's was anywhere in the world for she was enthralled by every inch of it. Aldeburgh was part of her marriage contract – and her love for Denis. Thus we drifted and toiled through the Fifties, young, a little inner society making its way to nowhere in particular. Political events such as Suez were 'noises off'. Although what had happened to Leon, Kurt and Gretl would never be this, and I understood it from the first.

Kurt plunged into the sea whatever the temperature. A large tawny old man, he was asking it to prolong his existence. He looked remarkably Aryan to have a 'J' on his passport. Knowing nothing about him at this time I did not glimpse the cavalry officer or the Oxford law student. But I could see the sunken lines made by tuber-culosis on his face. When *Picture Post* asked George VI which of their photographers they should send to take his portrait, he said, 'The nice, quiet German gentle-man.' The Aldeburgh sea crashed and roared, hissed and crunched below all kinds of incomers at this time, providing rough horizons. Britten would run into it late at night carrying a towel. Jo Ackerley, coming to observe it for the first time, marvelled that I could reach it with bare feet. He thought it was the flint equivalent of walking on hot coals.

Britten commissioned Martin Shaw's setting of 'God's Grandeur' for the first Festival concert. Peter Pears sang it – his first Aldeburgh song. All I can recall of him was a quiet watchfulness as Ben spoke, a nervous

smile, a self-protective courtesy. He liked artists and collected paintings. He would ask me about John Nash and Cedric Morris. He had a special love of what are now called the New Romantics, John Minton, John Craxton. I think that Britten was more taken with the surprising things to be found in Suffolk churches. They found a fresh symbolism in his music.

11 At Strafford House

Most evenings between writing my novel and toiling on the Festival I would walk along the Crag Path to be loved and fed by Juliet Laden. On the way I would pass Strafford House with its attention-drawing plaque to Edward Clodd. This was where he held his Whitsun weekends for Rationalists. Stimulated by W. R. Rodgers's Third Programme Dublin biographies, I began to consider a radio reconstruction of these Victorian parties. I tried the notion out on Imogen.

'What a splendid idea!'

One of Imogen's virtues was that she always knew exactly when to go on and when not to begin.

'Clodd's widow lives up by the golf course.'

'His *widow*?'

The famous rationalist was born in 1840.

'His second wife.'

Clodd married Phyllis Rope in 1914. She was a young biologist. He was seventy-four. I found her address in the telephone book and wrote to her. Her companion, Miss Grant-Duff, let me in, a tall smiling woman. Their bungalow was de luxe with a polished parquet floor. A gun was propped up by the hat-stand. 'Rabbits,' explained Miss Grant-Duff. 'Or golfers!' Tea had been

laid in the sparkling kitchen. A big fruitcake and generous cups. Buttoned leather armchairs. An Aga warm as toast. And Edward Clodd's *Memories* and Joseph McCabe's *Edward Clodd* on a side table.

'Mrs Clodd won't be long – the books we give you.'

She steered herself through the stepless door apologetically, one hand on the wheel of the invalid chair, the other held out towards me.

'Oh, you are young!'

She was a bag of bones in a pretty summer dress. She hung to one side. Miss Grant-Duff filled the teapot. I sat between them and felt unable to get out my notebook and pencil. Mrs Clodd said, 'You are sitting in Thomas Hardy's chair – from Strafford House.' And from then on Clodd's widow and myself were engulfed in a torrent of literary reminiscences.

'You realise, Mr Blythe, that this is all hearsay! Ladies were not permitted to be a mile from those Whitsun dos.'

I explained how I hoped to reconstruct a kind of Rationalist evening with Thomas Hardy, George Meredith, George Gissing – all of them at dinner in Strafford House.

'How clever!'

Mrs Clodd looked exhausted and once Miss Grant-Duff had to steady her cup. But when I rose to leave they cried, 'Not yet!' and 'Have some more cake.' When I glanced at the two Clodd books they said again, 'They

are for you.' I wrote in them, 'Given to me by Mrs Clodd'. *Memories* was dedicated 'To my comrade-wife'.

Phyllis Rope had accompanied him as far as she could. A few days after my visit she and Miss Grant-Duff left a note for the gardener on the kitchen table telling him not to go into the bedroom but to call the police. I have forgotten exactly how they rationally ended their brave lives – pills, I think. Edward Clodd died two years after Thomas Hardy in 1930. They cremated him in Ipswich and rowed with his ashes, beyond the outer shoal which faced Strafford House. 'He died in the Epicurean faith,' they said.

On 11 May 1912 Thomas Hardy sent an Aldeburgh postcard to his sister Kate with 'Very quiet here.' It would find its way to U. A. Fanthorpe. Her friend Rosie Bailey tells how. They had met my friend Nigel Weaver at Saffron Walden, and had given poetry readings at the Fry Gallery.

Dear Nigel,

U.A. isn't here at the moment but she's asked me – because you'll be waiting for a reply – for the story of 'Very quiet here'. She was delighted to hear from you: she's (we both are) a great admirer of Ronald Blythe.

The poem came about by accident, when she was a writer-in-residence at Lancaster. She was invited to talk to the students on Hardy's Titanic poem 'The Convergence of the Twain' . . . She was delighted and amused

at the perfunctory nature of some of it; even great men
apparently use clichés on postcards. She tried to imagine
what wouldn't be classed as 'quiet'. It was all happen-
ing in Dorchester, and it had been happening in Alde-
burgh, but that was in the past. She thought of the
future, too: his second marriage, World War I, his burial
(a corpse with no heart); and she gave Hardy a premoni-
tion of Benjamin Britten (though – as often with
personalities – the message is confused by the receiver).
As for Clodd, she knew of this friendship, and that
was why Hardy visited Aldeburgh – and of course she
couldn't resist the rhyme!

 Rosie Bailey (pp U. A. Fanthorpe)

VERY QUIET HERE

In Wessex no doubt the old habits resume:
Fair maidens seduced in their innocent bloom,
May-month for suicide, and other crimes
(The Dorchester murders discussed in *The Times*),
Mutilation of corpses, infanticide, rape,
And so many reasons for purchasing crape,
All stirring at home. But here vacancy reigns;
I have nothing to watch but my varicose veins.

Very quiet here.
Not an apprentice has perished this year.

At Strafford House

I envy Crabbe the matter that he saw:
Those wasting ills peculiar to the poor,
Decline and dissolution, debts and duns
The dreary marshes and the pallid suns –
So much for him to write about. And I
In Wessex homely ironies can spy.

None of that here.
Even dear Emma a trifle less queer.

Deck-chaired and straw-hatted I sit at my ease,
With each blighted prospect determined to please.
Inside my old skin I feel hope running on –
Perhaps a changed life when poor Emma is gone?
Strange foreknowings fret me: guns, music and war,
A corpse with no heart, a young Briton ashore
Walks here where I sit with the atheist Clodd,
Discussing the quirks of that local cult, God.

I ponder how
Time past and time to come pester me now.

U. A. Fanthorpe

Edward Clodd and the Aldeburgh Rationalists were
worried about Thomas Hardy's church attendance.
Their anti-faith pleasantries could hit a brick wall.
'We generally snatched a day from Whitsuntide',
wrote Clodd,

to drive to Framlingham, and I recall a witticism by Professor Flinders Petrie when he and Thomas Hardy were of the party. The Crown and Castle is faced by a large shop across the front of which is (or was then) affixed in bold gilt letters GEORGE JUDE three times. 'Well,' said Petrie to Hardy, 'you wouldn't call that Jude the Obscure.'

Probably thinking of walks on the Aldeburgh marshes, Hardy said, 'I keep on the causeway between the bogs of optimism and pessimism', when Clodd's guests were discussing novels. George Meredith was a fellow guest. He had worked as a reader for Chapman and Hall and had turned down Thomas Hardy's first novel *The Poor Man and the Lady*. Now Hardy was the greatest writer of the age. And there they were, all crammed together in Clodd's nice house with its double balconies, and the herring boats tipping the horizon, talking shop but now and then having to defend themselves against the coarseness of male conversation. The common bond was non-belief. But it took many forms. In Edward Clodd it had none of Matthew Arnold's melancholy washed-away certainties as he sat on Dover Beach, but contained an irrepressible thankfulness as the shingle in front of Strafford House repeated to him over and over again its scientific facts. It had dictated to him a bestseller called *The Childhood of the World* (1873), for Clodd was nothing if not evangelistic. As a

boy he had been imprisoned by Aldeburgh Baptists, made to sing horrible hymns and believe horrible tales, and in a horrible chapel. Although bile coloured the last. Built the year he was born, it remains a perfect brick box for language. Its dimensions and furnishings are still all that the speaking voice needs. And no sooner had I read Clodd's antipathy for it than E. M. Forster decided to talk about him in it.

Clodd was robust and emancipated. He went into the City aged fourteen as a clerk in the Joint Stock Bank and retired from it when he was seventy-five. He became a clubman – the Savile and Athenaeum – and a brilliant populariser of the new Darwinian landscape. He turned his parents' cottage into an elegant seaside villa in which, every Whitsun, he entertained most of the new God-emancipated world, T. H. Huxley, Sir Leslie Stephen, Sir Frederick Pollock, Thomas Hardy, George Gissing, George Meredith. He took them through the Suffolk lanes in his carriage and up the Alde in his boat. He is one of the great Victorian name-droppers – although never those of his wife and seven children. Where did they spend their Whitsun? He adored the cadences of the Authorised Version of the Bible and read them as literature not religion. And all should have gone swimmingly had it not been for Hardy. You knew where you were with Edward Whym-per – *Scrambles Amongst the Alps* – who, when asked if he would have porridge said that he would rather leave

the house! Whymper's role in a climbing accident – that he had cut the rope which held four other climbers in order to save his own skin, and sent them to their deaths, hung around him. When Thomas Hardy saw the Matterhorn, this never-to-be-cleared-up accusation was remembered.

> Thirty-two years since, up against the sun,
> Seven shapes, thin atomies to lower sight,
> Labouringly leapt and gained thy gabled height:
> And four lives paid for what the seven had won.

In 1865 Whymper himself wrote: 'They passed from our sight uninjured, disappeared one by one, and fell from precipice to precipice on to the Matterhorn Gletscher below, a depth of nearly 4000 feet.' You could not have written this if you had cut the rope. In 1916 Hardy read his poem to Whymper. The great climber filled Strafford House with pipe smoke. I imagined the tobacco-stained ceilings, the fetid bedrooms, the cook and the maid, the robust talk, the toasts to the death of God. The Fabians saw Strafford House as a comedy. They held their summer school at Stratford St Andrew just down the road. H. G. Wells satirised Clodd as 'Boon' in a wicked novel. Conventional Suffolk wondered what on earth it had done to bring all these peculiar people to it – socialism! But Edward Clodd was not a socialist. He was the grandson of a Greenland

whaler, a non-stop reader and talker, a giver not a taker, and what we can only conclude must have been some kind of enchanter. Or how else can he have filled Strafford House, Whitsun after Whitsun, and his London residence with the Who's Who of post-Darwinian Thought?

'Yes, dear, try,' Imogen had replied. But somehow the second Mrs Clodd and her friend said, 'Don't.' It was they who attracted me, not the smoky old clubman and his certainties, his energy, his undoubted brilliance with the London Joint Stock Bank. Edward Clodd, thou shouldst be living at this hour. Not all Victorian banks were steady as a rock, and their diceyness became a lever with which to upset the action in Victorian fiction. It was riches to rags when a Joint Stock Bank failed. It was suicide, the debtor's prison, the bailiffs, the shame. Clodd should have run them all. It was when he was made Chairman of the Rationalist Press Association in 1906 that H. G. Wells saw him for the first time and hit him hard. In a man who had read so much, done so much, been respected so much, *Boon* was a terrible blow. It was also not a very good book.

From now on and until I left Aldeburgh I ceased to think about the radio play. Or in Strafford House's case, the recovery of its conversation, and Thomas Hardy's unsatisfactory answers in particular. In 1978, when Macmillan published the New Wessex Edition of Hardy's work, P. N. Furbank asked me to edit *A Pair*

of Blue Eyes, which was Proust's favourite Hardy novel.
I was myself by then half in Cornwall. The Aldeburgh
Hardy, with its picture of him and his second wife
seated by the laundry in front of Strafford House, had
been overtaken by the St Juliot Hardy, and by Emma
wildly riding above Beeny Cliff in her blue dress. And
by the 1912 love poems which I read over and over
again. Ben set some of them for Peter to sing.

James Turner had now left Suffolk for Cornwall and
together we mooned about St Juliot. The strangest
thing had happened forty years after Emma and Hardy
had met there. The day Emma died he read her account
of their first meeting for the first time. He went to her
desk and there it was. It was identical with his account
of it in *A Pair of Blue Eyes*. And thus the 1912 love
poems poured from him. But not until he had himself
revisited St Juliot – and soon after he had married
Florence Dugdale, the girl he had brought to Strafford
House when Emma was ill and alive. There was a
moment when Edward Clodd felt trapped by Thomas
Hardy – felt compromised. Felt that Hardy was capable
of anything. And there were these strolls to Aldeburgh
Church not to mock but to pray. Or to pursue some-
thing which could not be explained, especially to
Edward Clodd. Hardy's churchmanship created the
cadence of his poems. It also provided him with a sen-
suous sound, such as the hiss of women's clothes as
they knelt and stood, a kind of collective statement of

Sunday best. But unlike the youthful Clodd, who had wandered from preacher to preacher in London to hear learned things as a course of education, rather than salvation. Hardy listened to the slow, meditative and often torrential tide of the singing – men and fiddlers at the west end – or to silence. When I told Rupert Godfrey, the vicar, about Hardy at Aldeburgh, he said, 'I suppose we do have to have him in your guidebook?'

His successor, Canon Oram, entered it for a competition. I wasn't told about it and went to a City church in London to receive my prize – £150. John Betjeman sat in the crypt beaming behind a pot of flowers. There were refreshments, wine and canapés on a table. The barrel ceiling was studded with marble tablets. The author of the first-prize church guide could not be present so his rector accepted it for him. When John Betjeman gave me the second-prize cheque Canon Oram snatched it from my hand and put it in his pocket with, 'I think this belongs to us' – i.e. Aldeburgh Church. John Betjeman rose and pointed at me. Canon Oram gave me a hug; but not the cheque. Walking in the late afternoon sunshine to Liverpool Street station I began to rehearse the preliminary rites of Canon Oram's unfrocking. I was later told that at the PCC meeting he had said that if it had not been for his entering my guide for the competition no one would have heard of it, I being so hopeless about such things. And he wrote me a letter of thanks for my generosity.

And the guide would sell for half a century. I gave a copy to Ben and did not put two shillings in the box.

Where it was Ordeinede that that the Maisters of everie Fyshere goinge a fishinge should take upp one thowsand Hearinges to the Townse use paieinge into thands of the Churche Revers vi^s viii^d for the same It is nowe by the hoole assente of the Ballyves and Burgesses altered That from hensforthe everie man shall paie for everie Doole that they shall laie, iiii^d onlie and no hearinges, And the Ownere of everie Fishere or boate to receyve the same at the reconinge And to make paiemente therof into the Chamberleyns hands to the Townes use before the Annunciation of our Ladie than nexte followinge under paine of xiii^s iiii^d to be paid to the Townes use

I heard that Benjamin Britten dreaded the meetings he had to have with Rupert Godfrey to do with the hiring, if that is the word, of the Parish Church for the Festival concerts as much as Rupert Godfrey dreaded his having to discuss them with him. Until I was sent to Blythburgh in 1956 to negotiate with a beyond-Aldeburgh church the increasing presence at home needed great tact. It was not only the performances but rehearsals, the rearrangement of seating, the introduction of stages and, sometimes, all the requirements of a concert hall being met with. Rupert wrote and spoke, 'Remember you are in a church.' Yet the music and those listening to it denied secularity. A forgotten holiness was making itself known. One look at Imogen's face as she conducted the rehearsal for Ben's *Saint Nicolas* cantata, for example.

I was singing in this when, in the midst of the rehearsal, an impressive European bass came into the church and Imogen dropped her baton and ran to him. He was wondering where he was to stay – the Uplands of course! 'Oh, you *are* so lucky!' cried Imo. He had walked from the station with a heavy case. No, of course it wasn't far – it was just across the road. And out they

went together. In a minute or two Imo returned and we began singing again. Perhaps ten minutes passed before there were amazed shouts. The bass had returned, disbelief in his voice. Imogen, all of us, stood transfixed. After a kind of roaring we began to hear what was being said. 'Never, never have I been so treated! *Never, never!*' He had been taken through the hotel and into the garden and been shown 'a chicken hut'!

He had in fact been shown Aldeburgh's highest form of accommodation, one of the pretty brick lodges in Connie Winn's garden. These were craved for by visitors. They were unique. And in the main house itself there was comfort and taste – and food – such as no conventional hotel could ever dream of offering to a visitor. The Uplands was run by Connie Winn who I used to think had escaped from a novel by E. F. Benson. She was the daughter of the late Arthur Winn, the best Aldeburgh historian, whose work I devoured and which was the kind of brilliant putting together of often fragmentary facts, which I adored. He was the kind of lifetime researcher of actuality for which no writer of fiction could cease to be grateful. Connie was his only child. She had inherited the Uplands. It was where George Crabbe had been apprenticed to an apothecary, and where Newson Garrett had put down his Aldeburgh roots.

When Ashley Courtenay stayed there in 1950 – *Let's Halt Awhile in Britain* – he found the Uplands

like an exclusive London club. It does not even bear
a number on its portal . . . I found myself in an old-
world atmosphere of grace and welcome, warmth
and comfort . . . I stepped through the Regency
drawing room into the garden, and, in the shade of
a gnarled mulberry tree, talked with Miss Connie
Winn in what someone described as 'the best hotel
in England' . . . I looked through the Visitors' Book.
It was a Who's Who of the arts, and of the golfers
and the yachting world . . . I noted the books, the
flowers, the modern comforts . . .

And when I was taken there by Denis and Jane Garrett,
we all noted – it was impossible not to – the butler
sitting a few feet off doing petit point between courses,
and Connie seated at the head of the long table which
was anything than a version of an inn's 'ordinary' such
as George Herbert described. The Uplands was extra-
ordinary. So was Connie. She painted, of course. Her
butler and cook had been with her for ever, of course. Her
intention was to cast her spell, especially at dinner. It
had something to do with the country-house pleasures
of the Edwardians, their essential simplicity and 'every-
thing of the best'. This meant a certain fadedness.

'Heavens!' said Imo, having got the singer into the
Wentworth. 'Now, where were we?' This may have been
the recorded *Saint Nicolas*, I am not sure. Sometimes an
interruption becomes the only memory. Connie Winn

ran art classes and my friend Anthony Atkinson told me that his life class was heavily subscribed by elderly gentlemen students. There was a plaque to Newson Garrett, the builder of the Maltings. In a sense all the 'remarkableness' of Aldeburgh found a footing in this house, it had been a short-stay on-the-way address for so many.

But Connie's father Arthur Winn would have been uncomfortable with his daughter's version of the town. In 1925 he had found Aldeburgh's *Order Book for 1549–1631*.

'The writing is good as a whole . . . but it has been necessary to revive the ink in many places before transcription was possible.' And so whilst others were deep in the Twenties, playing golf and 78s, he was deep in an Aldeburgh which was not submerged in George Crabbe, an extraordinary Shakespearean task which was more akin to *The Tempest* than to Suffolk.

We were distracted by Eden and Suez; I was absorbed by Arthur Winn and his 'briefe note where to find everie ordere'. Thus these Tudor and Jacobean instructions on how to be a true Aldeburgh burgess, having at one's fingertips

an order for strangers coloringe themselves to be free (black people whitening their bodies), an order for fishing doles, for digging of sand, for stallers of the market, for spirlinge boats for going to the sea

upon Christmas daie, for those that are talken of
this Towne in inconvenient places, for imprison-
ment, for carts, for marketfare, for an order for
going to the Skarborrowe seas, for making Appren-
tices free, for gravell, for gowns, so helpe you God
and his Sonne Jesus Christ.

I praised her father to Connie. 'Him and his old books,
dear.'

The town had a long tradition of acting as isolated
communities often do. Connie's father Arthur Winn dis-
covered in the Aldeburgh *Order Book* and elsewhere a
great emphasis on municipal, rather than religious,
parade and dressing up. Also that it was a stop high on
the travelling players' list:

They travelled in caravans, with their wives, chil-
dren and servants, living in covered carts, wagons
and tents . . . the journey always made at walking
pace . . . A circuit round England often lasted
three years or even longer; the Earl of Leicester's
Servants were here in 1573 . . . the Queen's Players
seemed to have delighted Aldeburgh audiences
more frequently than others. The following are the
names of other companies rewarded by the bailiffs:
Lord Bath's Players, Lord Sheffield's Players, Lord
Robert's Players, Lord Howard's Players, Her
Majesty's Players.

Whether Aldeburgh had its own Rosencrantz and Guildenstern the *Order Book* doesn't say. Maybe climbing the rough road to public worship in their showy gowns was amateur theatre enough.

Imo's enthusiasm for there being no non-performers in life made her keen to have the local players in *The Dumb Wife of Cheapside*, a comedy by Ashley Dukes, and for me to describe it. It was all about Alderman Groat who is married to a pretty wife – who is dumb. He calls in the medics – against legal advice. The apothecary–attorney is much against having anything done. It is best to leave well alone. But when the apothecary, the surgeon and the lawyer join forces a miracle has to happen, and Mrs Groat's tongue is released. She now talks non-stop. Her voice is heard all over Cheapside. Her garrulity drives London mad . . . Who or what can shut her up – or just give her pause? Dukes has stolen his play from Rabelais but it is a lively theft.

People once had fishy names – Bass, Carpe, Crabbe, Pike, Playce, Sammon, Shrimpe, Spratt, Turbutte, Wale, Whiting. Food included a lot of 'mackeral fare'. There were many drownings and local men and unknown men washed up by the sea were carried in the same coffin to their graves. Strong winds were not able to blow away the smells which filled the church and the rushes, broom and straw which carpeted it became 'verie noisome'. Hence the following bill for perfume (only an historian like Arthur Winn would have a nose for such items):

To Gates for pfume	4d
for pfumes and Frankinsence	1s 2d
To Mr Oldringe for pfume oyle and Frankinsence for the Church	1s 6d
To Mr Oldringe for pfumes at Christide and Easter	3s 0d
For rushes for the Towne Hall	10d

The most poignant expense at the Parish Church was the ten shillings paid to Robert Fowler in the seventeenth century 'for looking to the clock and for killing owles'.

Having just been given her father's book (by Rupert Godfrey) I ached to talk about it to Connie Winn. But somehow she had left Aldeburgh for E. F. Benson's Rye, and was out of reach.

13 My Guru

James Turner's protective anxiety that 'Aldeburgh' would take me over had substance. Although, during those post-war years, it was he who had taken all of us over, myself especially. It was one of those book-laden friendships which dominate youth. We talked, dreamt and 'lived' writing. He and I, not quite a generation apart, could think of nothing else. I would give up being a librarian because of him. His wife Cathy, plain-speaking and challenging, kept the pair of us in some kind of check. She broke in on our conversation when she thought us too far sunk – 'James!' It was like calling a dog to heel, I used to think, resenting her authority. But she knew what the rest of us failed to comprehend, that the bouts of 'bronchitis' she would nurse him through were in reality tuberculosis. She took him home early and I said that she was like Jane Austen's Mr Woodhouse, who thought that the sooner any party ended the better.

James was a shabby, pipe-smoking, round-shouldered poet in his forties with rich dark hair and a captivating voice. He was passionate, fired up and every inch a guru. Women adored him. Ours was one of those friendships of the time which was fuelled by the freedom of the

war being over. Limitless possibilities stretched before us. He wrote stories about strong women and vulnerable young men, country houses and ghosts. Also some good poems. His intention was to be like Cecil Day-Lewis whose prose alter ego was 'Nicholas Blake'. But James did not possess an alter ego. He was complicatedly in his books rolled up into a single voice. We, myself especially, lacked all criticism. He was our pattern.

Following James in his schemes and in his bewitching talk, his strait-lacedness and his constant house moves became for some of us a Pied Piper business. I suppose what occurred was that he seemed to me like the personification of a 'road' which I had to take, although heaven knows how. But it was no discipleship. Simply some kind of mutual progress which would make our 'way' the easier.

In 1947 James Turner had bought all that remained of Borley Rectory on the Suffolk–Essex border, a grim coach-house opposite the parish church – notionally though not truthfully 'the most haunted house in England'. We met the same month. He intended to grow mushrooms in the sheds, sell them to London hotels and make his fortune immediately cartloads of horse manure arrived at the gate. James's chief rival in this field was the artist Christopher Perkins who had built an actual mushroom factory in Sudbury, which was a far cry from tumbledown sheds. He labelled his

harvest 'the food of the gods'. There was room for us all, he assured us. The mushrooms would allow us to write, paint, idle even. They would keep us. I helped turn the horse manure in the dark stables. It steamed in the blackness whilst the mushrooms themselves gave off a psychedelic glow. We picked the mysterious fungi which seemed to come from nothing overnight, with a smell that was both deathly and promising, and filled the rush punnets. The London hotels, James told us, were craving for them. His enthusiasms were our gospel.

Amazingly, we found our fantasies underwritten as it were by two masterpieces, *Titus Groan* and *Gormenghast*. Printed in hard-to-read black letter, these novels overwhelmed the pair of us. One day Christopher Perkins gave a dance in his ancient house where my partner was like a James Turner heroine, although not a lady. An acrobat in fact, from a local act called 'The Garcia Three'. She was strangely muscled and her bare arms were like a boxer's. As we whirled around I told her about Mervyn Peake's novels as at that time neither James nor myself could talk of anything else.

'I know him,' she said.

I did not believe her. I actually considered her illiterate. But the following morning she asked me to meet him – James Turner too. At 7 p.m. we appeared at a cottage in Bulmer, a village next to Borley, and were taken into a room hung with framed circus posters which advertised the Garcia Three's parents having

performed before the crowned heads of Europe. There was a blazing fire and on a couch – Mervyn Peake. He was tall, with sunken violet eyes.

We talked sotto voce in the hot little room about the grotesque element in Charles Dickens, the physical distortion of so many characters, his pathetic, even ruthless exhibition of the malformed, the held-back sex because of his polite readership, and the exposed pitiableness of both his London and his countryside. The elderly parent-artists brought us cake and wine and made us all welcome, whilst their daughters amused themselves at our expense. Doubting Thomases!

Mervyn said that he had so hated being in the army that he had created an alternative world – Gormenghast, into which he could flee. This world was a kingdom-size castle. There was a women's unit near by where he met the two sisters whose bodies were like those of boxers. They modelled for him. They became friends – hence his being here. He and I also joined up, as it were. We wrote to each other, he in brown ink and stiff brown writing paper. He sent me his poems, *The Glassblowers*. I confessed to him how I wanted to stop being a librarian and become a freelance writer and he said I should. I found his wife Maeve Scott Fitzgerald's *Tender is the Night* which she longed to read. And he asked me to stay with them in Kent – but I never went. Just as I was devoted to James Turner, so I was to Mervyn Peake. All this in my late twenties. When I

went to Aldeburgh James believed that it would 'corrupt' the growing literary scene which he and I were becoming part of – that it would take me away from where I belonged.

Soon after this James and Cathy went to Cornwall, and a flood of letters began. Not only were they psychics, they were also movers. They would turn down a house for its absence of ghosts just as most people would for its lack of plumbing. Continuing to be overpowered by James, I wrote ghost stories for his anthologies without in the least believing in them, although fascinated by the genre – and of course by M. R. James. And eventually by Henry James when Britten composed *The Turn of the Screw.* M. R. James used to stay with his grandparents just below Aldeburgh Church and, it was said, experienced his first ghost in the church when he was a child, rushing from it during a service, terrified and at the same time observing it.

When I told James that I was about to try to put down roots as a full-time writer in Aldeburgh it momentarily halted him in his tracks. He looked at me gravely. Aldeburgh was not for him. But it took me ages to accept that he and I ran along different tracks. For example, I thought that everyone was a child of the Beveridge Report, and that the re-emergence of Churchill and the 'Suez' question were no more than part of the death throes of the old politics. What I failed to recognise was that James wanted the old days

back. Yet it was he who introduced me to Benton End and to all kinds of people both in Suffolk and Cornwall whose lives were wildly unconventional. I was twenty-five when he took me to meet Cedric Morris and Lett Haines, unconscious denizens of the old, dying bohemia.

We wrote copiously to each other for the rest of his life – he in a spiky gothic hand, or on a tall Remington, myself with a gentle underlying apology for going my own way. I spent Christmas with them and they examined me for signs of East Anglian corruption, as they asked direct questions. Especially about money. 'And Benjamin Britten – how are you getting along with him?'

Soon Mervyn Peake would slip from our sight into a truly Gormenghast sickness. Soon he would be unreachable. His letters fall about in old elastic bands. James Turner's fill a box. Mine to him are inextricably in Australia, guarded by Cathy's only relative, someone none of us had heard of. Scraps of our early days flutter about like old decorations. Mervyn's puzzled question, 'Why had the publisher printed *Titus Groan* in black letter?' James Turner's worrying, 'How can you expect to write in Aldeburgh?'

The Fifties were a glorious age for fiction. Should I even now find a copy of *A World of Love* by Elizabeth Bowen, *Picnic at Sakkara* by P. H. Newby, *Confessions of Felix Krull* by Thomas Mann, *The Towers of Trebizond*

by Rose Macaulay, or *The Flight from the Enchanter* by
Iris Murdoch in the bookcase, I am back to a roaring
shore with the fishermen saying to each other, 'There
he is. Hasn't he got work to do?' Oh, bright post-war
world to have such novelists in it! In Cornwall James
was saying much the same. The wildness of the rocks
suited him better than the wildness of the shingle. We
would sit on the dizzy headlands and let the Atlantic
rollers drug us into mindlessness. Whereas Aldeburgh's
sea conversed with me, James's sea was a great sound
without words. Although, not with all its listeners. A
few miles further on the twenty-nine-year-old church
restorer Thomas Hardy had found his Emma. And
astounding words of love at the last.

Inevitably James Turner sold Primrose Cottage for
the enormous sum of £7,000. Malcolm Arnold bought
it. He and I went up into his music room.

'No piano, Malcolm?'

'No piano, Ronnie.'

We all met again on Boxing Day.

'How are you getting along with Ben?'

How was I?

Malcolm's new wife and new son came in to be
kissed.

At three o'clock, the gale blowing, I said, 'Malcolm,
isn't there anything to *eat*?'

A two-foot-long Melton Mowbray pie appeared. All
I can remember now is the drink and the food. And the

miraculous blotto drive home. And Malcolm like Croesus because of the film money. And a music room with nothing in it. And Malcolm Arnold somehow not being where he should be. Although where was that? When he came to us for a return drink he said that he was writing Cornish brass-band music.

'They don't like hearing Malcolm swear,' said James when they had gone.

'But they all swear.'

'Not like Malcolm.'

I walked the whole length of Constantine Bay before I left. The blue sea was hazy, restrained and immense. It vanished from sight when I found a place to sprawl in the dunes, yet remained omnipresent allowing nothing else to sound or impose.

'Come again,' said Malcolm, James, everyone.

'There is a nice cottage up the road,' said Cathy. 'Only £800. Think about it.'

14 Sleeping in the Moot Hall

Who else has done it? Bored aldermen, centuries of thieves? It is an enchanting building. You expect to be able to lift the roof off and see the fretwork animals lying inside two by two until the dove returns with its twig. George Crabbe's only reference to it is as a prison. But he does give one of his rare benign portraits of an Aldeburgh official when he writes about its function in the shape of a fisherman mayor, a 'short stout person in good brown broad-cloth' coloured 'seaman's blue', who has 'been a fisher from his earliest days' and 'placed his nets within the Borough's bay'.

Where, 'by his skates, his herrings and his sols' he has amassed a small fortune of twelve hundred pounds. Which he kept in a box under the bed. My neighbour Eric had done this, and with exactly the same amount. So when the currency changed in 1972 he was in a panic for unlike the mayor he couldn't read or write, although I did discover that he could 'draw' his name. We sat a whole evening at my kitchen table as I taught him the value of the new coins and notes. And it took a whole week to persuade him to take his twelve hundred pounds of old money to the village post office.

As I made my bed in the Moot Hall it was a comfort to think of the mayor and his home savings and fisher-blue suit. Denis Garrett told me that when his cousin Elizabeth Garrett Anderson became mayor she took one look at the moth-eaten robes which generations of men had decked themselves in, the hat particularly, and had a dressmaker design something new and delightful for her to parade down the High Street in. The massive civic chair from which she ruled the corporation roost stood at the head of the table and I hung my shirt and trousers on it. There was a trapped June warmth in the heavy old chamber and a kind of boarded-up smell of meetings, crime and importance. Elizabeth Garrett Anderson and a whole gallery of worthies eyed me from their massive frames. The sea rocked the pebbles perpetually as usual just outside. Someone had rigged up a camp bed and brought blankets. I had brought pyjamas.

As well as mayors, the toiling naked bodies of J.-F. Millet's peasants surrounded me. The mayors were static, the peasants all movement. Their most celebrated stillness was in the famous and much reproduced study called *The Angelus*, when they heard the church bell, heart-stopping in its devotion, over the fields calling for prayer. The oldest bell in Suffolk still hangs against the spire of Hadleigh Church, put up there in 1280. But even if it was rung there would be nobody in the fields to hear it say *Angelus Domini nuntiavit Mariae* – 'The angel of the Lord brought tidings to Mary'.

J.-F. Millet had been hugely influential. Everyone from Daumier to Van Gogh had made copies of his drawings. Bernard Berenson had called him 'the stupendous Millet', and Roger Fry had described him as one of the great Moderns. But by the Fifties he had been reduced to *The Angelus* only, and this sentimentally. Sir Kenneth Clark, who had been brought up at Orford and who knew the Suffolk fieldworkers, had organised an exhibition of Millet's drawings to restore a comprehension of physical toil and its art. 'No painter of the nineteenth century except Van Gogh', he wrote, 'makes us think more seriously about the question how far art should concern itself with the great issues of human life.'

Clark had borrowed the drawings from Paris on the condition they were never to be left unattended. Thus my going to bed in the Moot Hall.

'Who will guard them?'

'Ronnie,' said Ben.

Needless to say that I dreamt of Peter Grimes being tried on the same floorboards. When the scandal of his treatment of boys broke and he came before the mayor and corporation, they recommended him to take 'a freeman whom thou durst not beat, not the defenceless children turned out of workhouses'. But Crabbe is enthralled by human compulsions, none stronger than to be cruel, violent, and excited by helplessness. Grimes's sentence was isolation. It caused him to become insane

and thus more violent still. His sentence was that of the scapegoat, a person driven from the herd so that all crimes against boys, a convention then, might be heaped upon him, freeing the conventional beaters from guilt. That Grimes was not imprisoned or hanged puzzles the modern reader. What he was given in this actual building was advice to choose legally protected apprentices, not unprotected orphans. Crabbe's real fascination with Grimes is the effect of social isolation and guilt on him. This poet is the master of madness. This pretty building was only a few steps from his birthplace, and further then from the sea. Its enchanting carved brick chimneys are early Victorian and 'borrowed'.

I locked the door, as I was told to do, before I went to sleep. Relieved by the day guard at eight in the morning, I bought two herrings for breakfast and went home to write my novel.

Half a century later Jane Garrett and I stood in this council chamber to see, not French fieldworkers, but the history of the Garrett family, the makers of farm machines and the monumental maltsters of Leiston and Snape, and reigning over them little imperious Elizabeth in her regalia. And there was the same richly enclosed odour which never left this room even when the windows were wide. The stocks had occupied one of the niches outside where I often sat to read.

East Anglia's J.-F. Millet was – still is – Harry Becker. It was at his exhibition in Ipswich that I last saw

Stephen Reiss. Becker's maternal grandfather had been a Baron and Chamberlain to the Grand-Ducal court of Hesse-Darmstadt but his father had settled in Colchester, renting the Minories, a great town-house which eventually would be the home of my friend John Bensusan-Butt. John was related to the Pissarros and Lucien Pissarro often came to stay there during the First World War. Harry Becker was born in the Minories in 1865. His descent, if one may describe it as such, from German aristocrat to penniless painter in the Suffolk fields was like one of Zola's remorseless novels. And yet he was able to show not only the degradation of the farm labourers at this time, when British agriculture was in the doldrums, and the servitude of those who kept it going through decades of slump, but also their physical strength, their actual movement as they toiled, and even their grandeur. The Waveney Valley farmer– novelist Henry Rider Haggard watched his men lay field drains in midwinter and was mystified by their grim acceptance of existence. Its reality was confirmed in Mary Mann's shocking *Tales of Dulditch*, her stories of farm labour in Norfolk. A Victorian rector made the labourers and their families stand outside his church whatever the weather until their betters were seated. Then they could come in and sit at the far back. Thomas Hardy knew them as great singers and fiddlers, also at the west end, but elevated to musical heights which car- ried worship beyond hardship, rank or what was

thought possible. Their studded boots struck sparks from the floor slabs. Both he and his father were skilled violinists and good singers, and helped to raise the roof.

Harry Becker's fall yet paradoxical rise to greatness was his becoming himself the horseman (ploughman) ditcher and shepherd as he worked, feeling their skilled movements in his own body – and being financially levelled to their existence. He and his wife Georgina settled in the Blyth Hundred, as remote a farming area as might be discovered at the turn of the twentieth century, a land which was still neo-medieval in many ways, lost, yet profoundly known to its inhabitants. Becker's penury went so deep that he would be seen sizing sacks to paint on. But it was his drawings which said more than any writer could about the people who worked the land. Their faces are usually turned away. Their clothes are voluminous, the trousers stringed below the knee so that insects were prevented from reaching their genitals, their movements accurate. Those same movements as in *Piers Plowman* or in *East of Eden*. Scything is one of Becker's perfect observations. But there is a brotherhood between Harry Becker in Suffolk and J.-F. Millet in France. So I thought as much about him as I did of the latter's work as the early light from the North Sea penetrated the limited windows of the Moot Hall. What the Garretts did at Leiston was to invent ways of obliterating sheer physical labour, to be able to lift eyes – and eventually after World War II to lay the

foundation of a farming which is virtually worker-free. So that I can now walk for miles in the Stour Valley through perfect corn and vegetable acres without seeing a soul at work. Without catching the bait-time talk and the thump of horses. Just in a new silence. Not even the Angelus bell, so no prayer, no hands together, no bowed head. And no arthritic flesh. And no movement unless the wind and rain makes it. Becker drew field-women – those same 'daughters of Tess' and who, like her, were out in all weathers. Hardy describes a farmer's wife having to do landwork after it had ruined him.

> One frail who bravely tilling
> Long hours in gripping gusts,
> Was mastered by their chilling,
> And now his ploughshare rusts.
>
> So savage winter catches
> The breath of limber things,
> And what I love he snatches,
> And what I love not, brings.

As a boy I saw pea fields crowded with pickers, beet fields lined with singlers, and the last of the harvest fields full of, well, everybody. Now David tills and sows my old seventy acres all by himself. But he would make a good Millet, a good Becker, although he makes none of the old farming movements, but sits aloft of them all.

But all rural writers mourn what they believe was a better life, that of the day before yesterday. Robert Bloomfield's *The Farmer's Boy* is a wistful idyll created in London. John Constable's favourite word for his countryside was 'serene'. George Crabbe in *The Village* weeps for the desertion of the land, and his merciless account of what happens to farmworkers when they can no longer work is unbearable. John Clare's arthritic father was made to chip stones to mend the Helpstone road when he could no longer sow and thresh. He was fifty, a famous storyteller and a good singer; George Crabbe would have taken a rounded view of such a man. He discovered in the Aldeburgh hovels undiminished people whose condition, as it was called, had not robbed them of intelligence and dignity, and whose lives ennoble *The Borough*. Drawn though Crabbe was to the dreadfulness of things, the Aldeburgh poor had to be celebrated.

For many years I lived in Debach and walked in Edward FitzGerald's and Crabbe's son's world. They had trodden every footpath, seen my trees, passed my house and were my neighbours. On this flat land they had accomplished my two classics, a 'translation' and a biography. To which I would add *Akenfield* – my view of things. George Crabbe junior was elusive, being overshadowed by his father. But Fitz had stayed vivid as eccentrics are apt to do. I frequently passed him, imaginatively speaking, on his way to the sea, drifting

towards the fishermen, grand, extraordinary, indifferent to comment. And his letters! Volumes of them, I would read them in the long grass by his grave and less than a mile from where they were written.

In nearby Parham other letters had arrived. Young George Crabbe was hoping 'to finish my book entirely . . . sometimes I think I cannot fail. Within these three or four days I've been remarkably high in spirits. I have somewhat exhausted them by writing upwards of thirty pages.'

The judgement of Aldeburgh was on its way. The Moot Hall would speak its mind. The French toilers on its walls would be translated and society high and low would be stripped naked. Although for some reason, especially in East Anglia, George Crabbe continues to be more mentioned than read.

My coming to Aldeburgh took me out of easy reach of both John Nash's Bottengoms and Cedric Morris's Benton End, which had been up until then the most influential places in my life. Just a few miles apart in two distinctive river valleys, the Brett and the Stour, these ancient houses became countries which I felt I had shamefully deserted. I would make laborious journeys to them and at times would become homesick for them. At Bottengoms I would clean the Aladdin oil lamps; at Benton End I would breathe in the rich odour of garlic, wine and oil paint as others did the North Sea. I would always make careful plans when it was Bottengoms because John liked to meet me at Colchester station. But the pair of us would simply turn up at Benton End, usually in the late afternoon, when Lett Haines, resting between the 2.30 lunch and the 7.30 dinner, would lean from his bedroom window and eye us wickedly. We would then search for Cedric in the garden, led by pipe smoke.

'Do you know what this is? I thought you had come to tell me.'

Should it be fine, old Benton End hands and still-nervous new Benton End hands would not look up from

their easels as we passed. They were quite unlike the usual art students, being both emancipated and trapped by the Morris–Haines ethos. We would pass grand old ladies, boys from Hadleigh ('the village' to Lett and Cedric), and well-known artists having a 'freshener', botanists and students of all ages. The Fifties were the heyday of Cedric's and Lett's East Anglian School of Drawing and Painting, as well as the zenith of the Benton End irises. Neither human being nor plant could remain very long in the gravelly soil of this art-cum-garden institution without putting forth some extraordinary creation. Some lived in – three to a room – others put up in the little town.

None of us knew much about Cedric's and Lett's life before they came to Suffolk. I heard that they had met on Armistice night in Trafalgar Square, that Lett was married, that Cedric had been in his thirties, that Cornwall beckoned, then Paris. Now in their sixties, they were to us old men. Lett's sophisticated talk and Cedric's curious innocence of manner combined to tell us about a past which we found simply amazing. Not that they cared for questions, unless of course they were about art, gardening or food. Lett's talk was unrestrained, sexy, funny, outrageous if possible. Cedric's talk was in a quiet, mildly Welsh voice and much interrupted by giggles. If we joined in with these it was usually out of politeness, for what made him crease up with merriment was a mystery to us. It would be years

later for me, as their literary executor, that the pas-
sionate and brave story of their lives would tumble
from letters and bills, and most of all from pencil lines
on dirty bits of paper. They had challenged Italian
fascism. They had befriended gay men when they came
out of prison. Lett had belonged to Ixion, the Anglo-
German League which sought to bring sanity to the
propaganda-maddened soldiers who had fought on the
Western Front, and what mostly enthralled me, they
had known everybody in 1920s Paris. Lett had been
friends with D. H. Lawrence, Hemingway and Gertrude
Stein. And here he was in Suffolk cooking our meals.

Neither did I think of Cedric as a naturalist, a bird
man, a botanist and plant-collector. In some ways he
was not unlike the poet John Clare as he made friends
with flowers. Lett was urban through and through, and
for all his sexual capers and sociability essentially
lonely. Young students called him 'father' and actually
loved him. But for all the activity of Benton End and
the affection it gave him, I used to think that he was out
of place. He had promoted Cedric's career and given
him the lead. Both of them ignored the caste system
and saw each person as distinctive and interesting – and
even now and then brilliant. Lett's eroticism was
bisexual and successful, and Cedric's little more than a
naughtiness which we found impossible to share. In one
way or another all of us 'flowered' at Benton End. It
was three guineas a week, bring your own sheets.

The food was peasant French. They were friends of Elizabeth David and Cedric had illustrated her cookery books. The entire house could at times reek of garlic, herbs and wine. Considering the conversation at times, dinner was formal – a simplicity carried to some exquisite limit.

Now and then, when Cedric was to have a London exhibition, Lett would say to me, 'Write the catalogue.' His own background particulars were never quite the same, and I would protest, 'But, you said this ... or that.'

'Never mind, dear boy, never mind.'

Of course I took Kurt Hutton to see them and recognised one of those indivisibilities of certain manners which belong to Europeanness. Cedric liked to harp on his Welshness but Paris and Rome, not to say Cornwall, had all made their mark.

Watching him paint was a bewildering experience. He did no drawing, no preparation; using bright colours straight from the tube, he began at the top left-hand corner of the canvas and ended at the bottom right-hand corner. It would remind me of those transfers we put on the backs of our hands as children, peeling them off gradually to reveal the full picture.

'Choose one for yourself,' he said.

I entered a dark old room off the kitchen and made out a backyard scene in the Algarve and dragged it towards him.

'You like that?'

'Thank you, Cedric.'

It wasn't signed so Maggi Hambling painted his name at the bottom. Washing hangs on the line, chickens run about. Lovely towers look down on a yard.

'Where are you off to?'

'Aldeburgh.'

Lett: 'Have we been there?'

I enjoyed Benton End best of all when John Nash was with me. It was then that I could walk behind the pair of them between the box-hedged iris beds and listen to gardening proper. So that when I came to Bottengoms for a day or two, and John Nash towards evening would say, 'Shall we go and see the boys?' and his wife would say, knowing that she would not have to cook the dinner, 'Oh, do, dears. They are always so pleased to see you', I felt a keen pleasure. A sense of belonging which so far Aldeburgh was denying me.

Sometimes Kathleen Hale, who wrote *Orlando the Marmalade Cat*, would be there. And often the teenage Maggi Hambling, or the Welsh artist Glyn Morgan, known in his youth as 'The Little Prince' because he was so good-looking. And Millie the housekeeper, a mite unsteady by seven o'clock, would lay the long table with wooden plates which we wiped clean with a bit of bread between courses. And the only heating in the house, an electric bar above Cedric's head, would be switched on and the toppling candelabra lit. The Benton End cats would disappear into the Suffolk darkness

while Lett in his butcher's apron would stand in the kitchen doorway and give us snippets of his and Cedric's scandalous adventures long ago.

'We were passing a café in the Rue de la Paix where two English ladies were sitting –

'"Who are those two young men?"

'"Oh, I think they come from Oxford."

'"Oxford Street you mean!"'

Should Lett go too far he would find a note from Cedric in his jacket pocket next morning: 'You were very bad last night.'

Twentieth-century art gossip is peppered with Cedric encounters. Here is Roger Fry in 1925:

> I met a really interesting man, a young English
> artist, Cedric Morris; he really charmed me, very
> uneducated but ever so spontaneous and real . . .
> He was all temperament and sensibility and
> genuine stuff and *très fin*, and not at all a fool
> anywhere and I liked him.

There was no music at Benton End – not a note. But always music at Bottengoms where there were two pianos. Schubert could be heard most evenings.

As scribe to Benton End I was required to tactfully tone down some of Lett's notes on Cedric for the Private View invitations. Here is Lett at his most florid:

Cedric was born, of phenomenal vitality, on
December 10th 1889. He was the eldest child of
George Lockwood Morris of Sketty, Glamorgan
(who, according to Burke, was descended from
Owen Gwynedd, the last Prince of North Wales)
. . . Bored and nonconformist in his father's house-
hold, he made off to Canada. [He was actually sent
off to New York with nine pounds to become a lift-
boy.] There he worked as a hired man on ranches
in Ontario where the farmers seem rather to have
taken advantage of his unusual energy and his *naïf*
ignorance of standard wages in the New World . . .
Eighteen months later he seems to have been
studying singing at the Royal College of Music
with Signor Vigetti whose attempts at raising his
light baritone to a tenor were unsuccessful. He
determined to study painting in Paris . . . In Paris
he industriously attended all the available 'croquis
libre' classes at the Académies La Grande Chau-
mière and Collarossi, Académie Moderne (under
Othon Friesz, André Lhote, and later Fernand
Léger) . . .

And so on, through gaudy Mediterranean travels,
membership of the London Group and the Seven and
Five (seven painters and five sculptors), helping to
found Welsh Contemporary Art exhibitions between
the wars, the settling down in Essex and Suffolk, and

the post-war plant-hunting and winter travels, when Benton End was closed, and Lett went to Brown's Hotel to 'economise'.

I once wrote that Cedric was a pagan who liked the sun on his back and the day's colours in his eyes, and the tastes and sounds of Now. On a really beautiful afternoon at Benton End he could be found lurking amidst the huge blooms he had brought to Suffolk from the Mediterranean, and hugging the Now to him, his handsome brown old face tilted a little skywards and his body helplessly elegant in brown old clothes. And that a conducted tour through the beds was both learned and hilarious by then, Cedric himself becoming convulsed by the habits of some plants – and of some of the people who came to see them. I was always intrigued by his catlike satisfaction with present time. It caused his days to become so long that, in spite of a stream of visitors, an enormous amount of painting and gardening – and teaching – managed to get done.

I was with him to the end. At ninety he cursed God, whom he still took to be some misery from Glamorgan, for 'insulting' him with old age but his sensuality never left him. He basked in the sun. Nobody has such a good time as a good-time Puritan. Being a non-Puritan, Lett had rather a bad time one way and another.

'Not a boring thing,' was Cedric's accolade for the Bottengoms garden. Very old and near death, he asked me, 'Do they touch your sleeve like this?', giving a little

attention-drawing pluck to his jacket. He was ninety-two. But in 1955 there was much time still to go.

The only gardener to give an expert account of Cedric Morris's plants, and his irises in particular, is Tony Venison. The Benton End Iris Party lives all over again when he speaks. Upward of a thousand blooms inhabited the box-hedged beds. Cedric adored painting them, taking them out of art nouveau, where they had decadently flourished for years and become symbolic of a movement, and making the gardening world see them as raunchy blooms 'sticking their tongues out', as one visitor said.

Each plicata (folded leaf) appears to do no more than rise from the surface of poor soil with the strength of a dagger, before it flowers with an opulence which suggests so many moving silks, from those of a jockey to the banners of a knight. The petals are 'falls' and 'standards'. When Richard Morphet from the Tate Gallery came to my house to write about them, he said that 'Cedric is one of the most exceptional colourists in British twentieth-century art. It is not only the intensity of his colours that tells, but above all the originality and strange beauty of the relationships between them that he established.'

I doubt if Cedric ever came to Aldeburgh or to the East Anglian coast. His coast was Portugal. There is no record of his ever walking from Benton End into Hadleigh High Street – into 'the village' as he called

this borough . . . Once home from winters abroad, burdened with rolls of canvas tied up with hairy string, and bags of seeds and cuttings, he went nowhere. We came to him – to the expanding three-acre garden, to the iris capital. Not surprisingly it made me see what flowered in Aldeburgh. If there was one thing there which Cedric would have admired it would have been the tenacity of its plants and their stand against the wind, their salty hues and ample nature. The way in which they stood up to things. Both at Aldeburgh and Benton End there was a bravura performance of gardening, each so contrasting, each so colourful. Each filled with movement.

When Kurt Hutton went to photograph Sir Cedric Morris at Benton End I saw how physically alike they were and, although German and Welsh, how similar in manners, and in how they were amused. Both had been on the Western Front, Cedric at Remounts behind the lines – and he who loathed horses! And Kurt as a cavalry officer. Not that any of this was mentioned. They met as artists – as outsiders. As part of my ever-growing Suffolk world. A painting of irises flared up behind Cedric's brown head in the photograph. Like a floral battalion on the move. It was in the upstairs studio which was never used if there was the faintest possibility to be outside.

16 Mr FitzGerald is in the Wood

CAPTION: Ronald Blythe at Great Glemham

In Aldeburgh various houses where Edward FitzGerald had lived were pointed out to me. He could not be said to have *lived* in any of them. Where Aldeburgh was concerned his living was done at sea. But I saw him haunting the beach at night as he compulsively made his way between the herring boats, recognised and unknown at the same time, his hat tied to his head with his shawl, his Irish eyes seeing and not seeing.

I was given *The Rubáiyát of Omar Khayyám* in Penzance when I was nineteen, and was as knocked out by it as any Victorian. FitzGerald had been introduced to the twelfth-century Persian astronomer–poet by an Ipswich boy, Edward Cowell, who said that he made it to live in a way that no translation has ever lived before. Be that as it may, no one bought it, and for years it languished with other little volumes in the booksellers' tuppenny box. When at last it was discovered by an Oxford undergraduate it mesmerised the young. My favourite explanation of it was written by Angus Ross when he and I were contributors to *The Penguin Companion to English Literature*:

Omar's quatrains are spontaneous, occasional, short poems; FitzGerald makes them a continuous sequence, sometimes compressing more than one poem by Omar into one of his quatrains. The FitzGerald stanza, with its unrhymed, poised third line, is an admirable invention to carry the sceptical irony of the work and to accommodate the opposing impulses of enjoyment and regret . . . There is a desire to seize the enjoyment of the passing moment, moving through the day until, with the fall of evening, he laments the fading of youth and the approach of death. Several interests of the time, divine justice versus hedonism, science versus religion, and the prevailing taste for Eastern art and bric-a-brac were united in the poem.

The fact was that when I was reading it in Cornwall, everyone else had ceased to do so. But for some reason what was fustian to others for me was fresh as a rose. He loved Aldeburgh, they said. But I doubt it. What he loved was the freedom of his boat and Posh Fletcher sailing it on the German Ocean. Fitz named it *The Scandal* after the main staple of Woodbridge, where the boat was moored. Although it was not his boat now, because he had given it to Posh. Posh, he told Alfred Tennyson, was beautiful like a Greek statue, thus a suitable companion for a gentleman, and he introduced them when the laureate was put up at the Bull in Woodbridge.

Many years later an old man from the workhouse was seen burning a pile of letters on the beach. It was Posh Fletcher signing off. When I heard this I thought of Samuel Palmer's son making a bonfire of his father's paintings and drawings in a Cornish cove because he was ashamed of them.

In 1960, staying at Great Glemham with Fidelity Cranbrook, I met a woman who was looking for someone to take on the last year of a tenancy. It was for one of those few-feet-from-the-road old farmhouses which may have been built 'for company', as it were. From which one could watch the world going by. This house was two miles from the grave of Edward FitzGerald. And only a mile away stretched the concrete plateau of a USAAF bomber station. My new house was owned by an old farmer named Harold French, who had used some of the compensation money for the turning of his fields into the aerodrome to mend the various properties he owned. Mine needed so much money to make it habitable that he called it French's Folly. It was beam and plaster, pantile and, alas, concrete. On one side it looked out towards Maypole Hill and its oaks, and at the back to Dallinghoo Wield, an untouched sequence of elm-sheltered pastures across which Edward Fitz-Gerald walked with his friend George Crabbe, son of the poet. Also with Lucy Barton, the daughter of the Quaker poet Bernard Barton. FitzGerald married her, which was a foolish thing to have done.

Anyway, the nineteenth century was not so much heavy on my heels at this moment as was an elated feeling of having settled at last. In retrospect I can see why both Christine Nash and Imogen Holst were disappointed in me. I had vanished. Debach – where was that? Well, Debach, population about eighty, stands on high ground and through its name flows a minute stream which some call a ditch. All over Suffolk this village is know as Debach Post because had not a sign been pointing to it, travellers along the Roman road would have gone straight on, to Wickham Market. There was an 1857 church with a coffered ceiling borrowed from Carlisle Cathedral, a mighty rectory, a straggle of old cottages and Thirties council houses, and a pretty pre-1870 Education Act school which had become a garden shed. Edward FitzGerald and Lucy Barton liked to drop in to teach the farm labourers' children now and then.

Very soon after my move into this unknown world, I became a churchwarden, really to take charge of a redundancy. The barely attended church, floundering in cow parsley and rich grasses, darkened by lilacs, had lasted almost exactly a hundred years but now had to be closed. I was told to give its contents to neighbouring churches, a chest here, a huge chair there. In the vestry hung an ancient mirror with its backing, a blotter, hanging among the splinters. When I held the blotter up to what was left of the mirror I read, 'Mr FitzGerald is in the wood.'

He was also just down the road sleeping beneath a rose from Naishapur.

> I sometimes think that never blows so red
> The Rose as where some buried Caesar bled;
> That every Hyacinth the Garden wears
> Dropt in her Lap from some once-lovely Head.

> While the Rose blows along the River Brink
> With old Khayyám the Ruby Vintage drink;
> And when the Angel with his darkest Draught
> Draws up to thee – take that, and do not shrink.

Omar had a pupil, Kwajah Nizami of Samarkand, to whom he gave instruction for his burial: 'My tomb shall be where the north wind can scatter it with rose petals.' In the 1890s, with the *Rubáiyát* all the rage and the Omar Khayyám Club in full cry, travellers to Persia came home with shocking tales of the state of the poet's tomb, which was a plaster structure without a name. Our minister in Tehran tackled the Shah about it. He was astounded when told that Britain was wild with Omar – 'Why, he has been dead for a thousand years . . . we have got many better poets than Omar Khayyám.' But of course they had not got an Edward FitzGerald. Meanwhile, back at the Club, there were rumours that its President, Sir Mortimer Darend, was hoping to be given the Persian Order of the Lion and

the Sun. So the nameless grave crumbled and the rose thrived.

An artist from the *Illustrated London News* went to see it and brought back hips from the rose to Kew, where it was propagated and brought forth medium-sized pink blooms, quartered with button eyes, and downy-grey leaves. A cutting from this bush was planted at the head of FitzGerald's grave, where it would have done all right had his every visitor not taken further cuttings. I remember finding a kind of green stump.

In the Seventies a later Shah, being told of this, commanded that *six* rose trees should surround FitzGerald. They could have made it difficult to read: 'It is He that hath made us, and not we ourselves' – the FitzGeralds' apology for such a strange member of the family. Someone who told the world that all his friends were loves. On a miserable November day I went to Boulge Church along with everyone for miles around to await the Persian Ambassador who was commanded to plant the Shah's roses. It was wet and cold. Two front pews were roped off for the ambassadorial party. The electricity went off and some of us went out to collect paraffin lamps and candles. The organist played all the introits he knew many times. The Rector, Mr Braybrooke, then climbed the pulpit: 'I am next in line, I suppose, to plant the roses.' Whilst he was heeling them into the mud, a Rolls-Royce appeared on the concreted path through the sugarbeet, its pennant flapping. It sent the rooks up.

The Ambassador was princely and smiling, very tall and wearing a coat with an Astrakhan collar. There were some smiling ladies. And a little boy.

'Oh, you English – you are so *prompt*! We came Newmarket way and had lunch!'

'We must give you some tea at the Rectory.'

'The English are so polite.'

'We will charge him for the printing,' said Mr Braybrooke.

Some years after this Sylvia Townsend Warner came to see me en route to Peter Pears. When I told her this story – it was a November afternoon again – she insisted that we all drive down the road to look at Fitz's grave: 'Oh, I must see it!'

She was writing the life of T. H. White and I was writing *Akenfield*, for which I had been stealing names from the Debach gravestones.

Sylvia: 'Names are so important, don't you think?'

We wondered where Shakespeare had found his names. Does anyone know?

Sylvia: 'Is Omar's name on Fitz's stone?'

'Only his.'

She was enthralled when I told her what happened to the FitzGerald crypt on the Debach and Boulge Flower and Vegetable Show day. It was a Gothic building with a flight of steps and a pair of doors, a heavy protective cast-iron fence and a curious solidity. At the Flower Show, the gates and the doors were flung wide

and we could enter. It was one of the Flower Show's sideshows. There were brass-studded purple coffins on stone shelves, one above the other, all very tidy as one should be in death.

'Oh, we must see it!'

I told Sylvia a joke about a Shah. 'The Shah of Persia sat next to a Scottish lady in Edinburgh who said, "They tell me, Sire, that in your country you worship the sun." "So would you, madam, if you had ever seen it."'

Sylvia: 'All this Persian thing – in Suffolk! – Wonderful!'

Persia had come to Suffolk in a fairly direct way. In terrible grief after his great friend William Browne, a Bedfordshire squire, had died in a riding accident, Fitz-Gerald had met a youthful Ipswich linguist at a rectory party who said something like, 'I could teach you Persian, sir.' This is how masterpieces take root.

I had been in my new old house only a month when an ancient man asked if he could scythe the paddock. We were sitting by the Rayburn and above it was the only photograph of Edward FitzGerald which existed. Or rather there was a pair of them from an Ipswich shop, one looking up, one looking down. He called the latter 'the old philosopher'.

Davy, the old man remarked, 'I knew he.'

'You couldn't have done. He died years before you were born.'

'Had a boat, didn't he?'

'He did.'

'I knew he.'

My house was protected at the back by a pond called a cattle moat. Even so, Harold's cows would now and then splash through it and surge onto the lawn. Usually in the small hours. It was a dreaded sound, the heavy breathing on the walls, the wrecking feet. I would rush out in my pyjamas and drive them onto the road and into the first meadow I could find. Harold the landlord's advice was to fill in their footprints with sand – 'You'd never know they'd been there.'

He and his elderly sister were frightened of thunderstorms. They would ring up at three in the morning: 'Can you come round?' They had come to Suffolk from Devon in 1919 when, as people said, 'You had to sell a sheep to pay the men.' Air Ministry compensation had transformed them: a Jaguar – I watched them blackberrying in it, slowly driving from bush to bush on waste land – a swimming pool, but still that old carefulness. He would bring me a mass of pea hulm which the lorries had left on the hedges as they rocked off to the Birds Eye factory. 'Enough for a meal,' he would say. Once when they went away the hotel put them into a double bed and it was 'All right.' Their innocence touched me. It was real.

Alone at Boulge and in what now seems to be always early summer, I would lie in the maidenhair and ox-eye

daisies by FitzGerald's grave and read a book. His lodge turned Thirties bungalow was near by and I handed out prize money at the celebrated Debach and Boulge Flower Show in it. Not that there was the least sign of his occupancy left. But the footpaths led straight to him in every direction. He filled the local pillar boxes with some of the best letters in the language. I found myself knowing FitzGerald through and through via his letters, which were indiscreet to a fault – as letters should be. And yet through my imagination and by living just up the road. And by talking to my shepherd neighbour from the Highlands who now lived on the FitzGeralds' Home Farm, but who would not have been interested in him.

The airfield had redirected so many of his walks. These were strewn with the dead. Dance-band music blared into his silence. Longings for Ohio and New York met with his indifference to where he happened to be. Why is there no longing for Ireland? Or for Cambridge, if it came to that. In his letters to Carlyle and Tennyson he mocked his few miles. But he could be formidable and attacked ignorant squires who cut down great trees. He heard church bells, this being ringing country. But I doubt if he knew that a bell at Charsfield was inscribed, 'Box of sweet honey, I am Michael's bell', only in Latin of course. He was not at all archaeological. Time for him was measured by the fall of petals, the taste of wine, friendships.

At Aldeburgh I used to wonder why he never came into Ben's and Imogen's thinking. But, born just before the First World War, they could have seen him among the bric-a-brac, trashily clothed in soft leathers and velvets. In Woodbridge I met Miss Howe, daughter of his housekeeper, who kept a shop in Church Street, and who brought out his inkpot and shawl to show me. All this would again have struck Ben and Imo as frowsty.

Driving across Naseby battlefield the other day, we passed and repassed one of those house-size container vehicles which read, 'Debach Enterprises' in big letters. Now it is certain that if my landlord's cornfields had not been flattened with Aldeburgh shingle by Irish labour, no one in Leicestershire could ever have read 'Debach'.

My landlord and his sister bought a pair of New-market racehorses with the airfield money, calling them Debach Boy and Debach Girl. Listening to a race on the radio they heard the commentator cry, 'De Bark Boy, De Bark Boy!'

'Really,' they said, 'you would think that an educated person would know how to pronounce Debach [Deb-bidge].'

All it has on the two-and-a-half-inch-to-the-mile map is 'Airfield disused'. No astronomers' language. No hint that it would be in use by Debach Enterprises and its far-flung customers, and known in Birmingham – and all over the world. What a way for a hamlet to go!

17 The Airfield

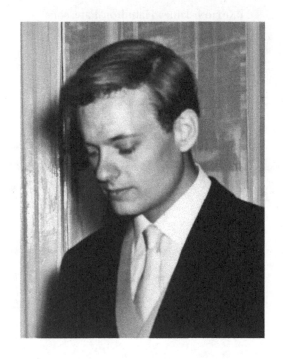

Debach and Boulge stand at a conjunction of Suffolk's light and heavy land. To the north-west lies 'the ol' clay', to the south-east the sandlings, and the sea. Here, there and everywhere black plantations thrived for the shoots. One winter a plantation was bowed to the ground by an army of rooks. The sandlings shade off all that is emphatic in our landscape. But the old clay never stops declaring its presence. 'Loving-land' the old farmworkers used to call it as it clung to their boots.

Debach airfield hung on to signs of its wartime inhabitants. I sometimes found letters in a rolling American hand in its concrete crevasses. The saluting base had sockets for all the flags. Now learner drivers sped where the bombers took off. When James Hamilton-Paterson and I became friends in the Sixties I discovered that he was fascinated by aviation. This was made known to me, not on Debach airfield but in my own garden. We were clearing a patch in which to grow vegetables when we began pulling out thin sheets of what looked like tin. Then we exhumed what seemed to be old clocks. And then we knew what we had found – a Spitfire.

Neighbours said, 'Oh, yes, poor lad. He flew off early one morning from Woodbridge and hit your elms –

which cut his head off! His head was up the tree and his body was still strapped in the cockpit!'

James and I washed the instruments in the sink and stacked the Spitfire sheets against the garage.

He and I were introduced after he had won the Newdigate Prize for Poetry at Oxford. He sat on the bench above the moat – 'I think I could be happy here.' He had just returned from searching for Che Guevara in South America. Everyone I knew was searching for something or somebody, the Maharishi, the Beatles, Flower Power, whilst I did not seem to be searching for anything, and was thought to have found it. But I hadn't. James Hamilton-Paterson and I were not seekers at this time other than after the means to exist. He sat in his room and wrote children's novels, and eventually, elsewhere, a masterpiece called *Playing with Water* which he dedicated to me.

Seas, oceans, not Suffolk ponds, would preoccupy him. Aeroplanes too. We walked the Dallinghoo Wield and he would fill his pockets with tin shirt buttons lost by farmworkers, also fossils; pouring these finds out on the kitchen table. I re-read *Playing with Water* because amongst all his books it 'holds' what we were then before either of us became what we are now. He was – is – tall, fair, patrician and unprovincial. Free of those things which have tied me to a small scene. Debach, the tiniest place imaginable, stays expanded by his friendship.

They were digging up Sutton Hoo again when I was there and I would cycle over to watch the amazing sand ship taking shape; the sand prow, the sand ribs, the sand keel. The sand destination. Once when the archaeologists had rigged up a vast plastic sheet against some likely rain and had taken their shirts off, the Saxon galleon looked as though it was in full sail and would reverse its voyage up the Deben and carry its memory of garnets, gold, harp, standard and banqueting silver to Scandinavia, leaving us with just a hole in the gorse.

Arrow-straight roads run to the sea from here. The featurelessness of them creates a kind of calm. The sandlings is a land specialising in departures and in returnings. Alun Lewis, stationed here during the last war, found it more than he could bear:

> From Orford Ness to Shingle Street
> The grey disturbance lifts its head
> And one by one, reluctantly,
> The living come back slowly from the dead.

James Hamilton-Paterson and I borrowed his mother's car to savour Dunwich. I knew exactly what Dunwich tasted like but it was all new to him. The cliff was sprigged with yellow bones where the final churchyard was crumbling into the waves. James found a perfect white and pale-gold skull, emptying the fine sand from it and placing it on the back seat. Five years

later his mother rang to ask, 'I've found a skull in a
biscuit tin. What shall I do with it?' I buried it in my
wood. No rites, other than tenderness. No sea sounds.
My mulch filled the whirled hollow of its ears. James
sent me a seahorse from the Philippines in exchange.
We had an investment in fragments.

I wrote:

Winter reveals vivid contrasts between the water
patterns of the two lands which meet at Debach.
On the sandlings they are anarchic, spilling far over
for miles beyond the estuarial limits and flooding
the shallow valleys of the Stour, Orwell, Deben,
Alde and Blyth. Thin bright lakes spread them-
selves with what appears to be a colourless deliber-
ation round our traditional defences. On the heavy
land being ploughed in front of my house the water
is still disciplined by medieval utility measures and
few Debach walkers could guess at the number of
its moats, wells, ditches and ponds. There is such a
variety of quiet trapped waters, few of them to be
seen until one almost tumbles into them. The field
ditches between me and Maypole Hill stay worka-
day as they churn incredible volumes of Tiber-
yellow liquid through icy cuts only half-a-dozen
feet below the growing crops. The sound of all this
half-hidden, half-heard water is the voice of our
arable winter. No babbling brook but 'a cry of

Absence, Absence, in the heart, and in the wood the
furious winter blowing'. Except that in East Anglia
the blowing tends to arrive with the spring. It is no
wonder that the oldest man-made structure in
Suffolk, according to M. R. James, is a wind-shelter
near Ipswich.

And there is Shingle Street from which Irish
labourers brought countless stones to make the
runways. The stones there exist in such mesmerising
quantities that, like stars, one must stop counting or
weighing and even thinking in numbers. A mile from
my house the bombers trundled over them on their
death runs. Pre-war maps directed us to brick-lined
moats, shadows of cottages, suggestions of paths, hints
of population. Perhaps two thousand years of agricul-
ture and rural habitation all smoothed out. But the same
air. The same plants. The seasonal birds coming and
going as they did above the Western Front. And a
handful of things which only Edward FitzGerald might
recognise.

James and I went to Aldeburgh, of course. Went all
over the county. He was bemused by my Anglicanism, I
was unnerved by his detachment. If I can see a long
way in East Anglia, he can see continental distances,
ocean depths – and flight paths. He is a master of minu-
tiae and of great things. Also, like me, solitary. Debach
became our interpreter, this hamlet, shorn now of its

crowning glory, the elms. I try to go this way to Alde-
burgh – to anywhere past Ipswich. The church is now
a house, and the family which live in it garden among
graves, and look out on fields which have shed their
concrete. But Dallinghoo Wield retains its old surface
on which curious objects still linger. French's Folly has
changed its name once more. But Debach is not a name
one can do anything about. It clings to its post.

18 The Sea

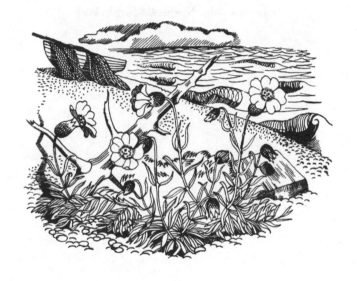

The sea, and whatever sea it happens to be, is in a permanent state of cancellation as far as human activity is concerned, eventually wiping out our every mark. Our history is eventually little more than the sea's litter. My friend James Hamilton-Paterson, one of its greatest recorders, said that 'the swimmer tries to remember what a mile looks like'. He was remembering how the sea takes our measurement. At Aldeburgh, although best of all on the north Cornwall coast, I give up attempting to keep in mind what is landward as I watch the sea hit the rocks like a restless sculptor with all the time in the world to shape them. My head becomes a tabula rasa on which the ocean is welcome to write poetry or gibberish without any guidance from me. Is this why old people retire to the south coast or Florida? Why their most treasured possession is a deckchair? Not a bed in the opium den but a seat where the most wonderful monotony can drug the watcher into forgetting past, present and future. Should it be warm enough there is no reason why, at Eastbourne, sea-nirvana should not be reached by elevenses.

However it is a young me who takes to the hot shingle with a notebook, an unread book and a canvas

windbreak in order to be hypnotised by the everlasting waves repetitively coming my way but never quite reaching me, and by the immensity of the water behind them. They make land seem a very trivial business.

Benjamin Britten, Lowestoftian from day one, might be said to have come out of the sea like one of those oceanic beings who blow horns in the cartouches of ancient maps. Unlike me he was oceanic from the start. Tides accompany his pulse, whereas my pulse is out of tune with the regular beat of the shore which I find wearying as well as stimulating. I have never seen Ben tired. He is either fully awake or sound asleep. His father's house stared hard at the sea in all weathers. It had a basement from which on Monday washday steam would billow in soap clouds which added to the morning mist, his sister Beth told me. It is odd how disconnected bits of human information become free from one's unforgetfulness, and gain importance. Thus the Lowestoft dentist's house and the little boy on washday and the composing – like Mozart.

In 1955, the year I came to Aldeburgh, Ben wrote the following:

Once upon a time there was a prep-school boy. He was called Britten mi., his initials were E.B., his age was nine, and his locker number was seventeen . . . There was one curious thing about this boy: he wrote music . . . He wrote lots of it, reams and reams of it.

(Between the age of five and eighteen, Britten com-
posed around 730 pieces of music.)

Beth Welford and I used to talk in the Bull Hotel at
Woodbridge. Her marriage had broken up and she felt
free. She told me about the descent of the Scottish
herring 'girls' in Lowestoft and the fishmarkets where
her mother helped to run a canteen. But what with the
Depression and the disappearance of the herrings, the
town during Britten's boyhood had become a struggling
place. His experience of it helped to create his Labour
politics, as did the agricultural depression form mine.
But *Akenfield* worried him. 'Are you against our Suffolk
farmers, Ronnie?' How could I be? He then agreed.
How could I be?

Our sea remained as it had been for ever. Out of it
came his music. Supposing, like me, he had come from
where he could not hear it?

'Dear, the things you ask!' said Imogen.

Preparatory to writing this note on it I would revisit
it. I would walk from Thorpeness Bay to Orford with
long rests here and there to find out if it was still speak-
ing its mind. Once I had cleared mine of its literary
lumber and its old emotions, and I had set my ear to its
sound, it sang!

People who write never fail to catch its voice. It made
the Second World War poet Alun Lewis desperately
unhappy:

From Orford Ness to Shingle Street
The grey disturbance spreads
Washing the icy seas on Deben Head . . .

The soldier leaning on the sandbagged wall
Hears in the combers' curling rush and crash
His single self-centred monotonous wish . . .

Burma would grant it. Everyone wishes that the
herrings would come again. Swim in their millions
from the Scottish islands to Cornwall. Be a silver
multitude once more. In Eastern England their not
arriving is still as though the moon had vanished. At
least their plenty did not make us mad like the Swedes
when herring gluts made the poor eat themselves
crazy. 'Pray to God the herrings never return!' they
said. It had been like *Whisky Galore*, only disgusting.
Once in Sweden they took me to the smooth rocks
above which the smokehouses and fishracks stood, and
into the fishermen's huts. There were group photo-
graphs like 'The Class of '93'. Males of all ages but
with the same alcohol-blinded eyes and drink-sodden
mouths. Boys and men who had drunk the winter dark-
ness away. Which is why in Gothenburg you can't have
half a bitter without a government permit.

In Aldeburgh and Lowestoft and Newlyn, herring
arrived regularly as clockwork until . . . ? But the exact
date is too awesome perhaps to be remembered. The

Dutch called their herring fisheries 'The Triumph of Holland'. Julian Huxley believed that the mystery of why the herrings stopped coming could never be solved.

I cooked them in oatmeal. 'They filled you up.' When I went to stay with James Turner in Cornwall, to be introduced to the last of the Newlyn School artists, themselves a rarity, we would walk round that fine harbour to see what was left of a huge fish industry being turned into watercolours. But I always tried to be alone at Land's End and at remote points, and at D. H. Lawrence's Zennor. Yet nothing there diminished Aldeburgh. Nothing modified its contemplative powers. Coasts provide the ultimate sites for meditation. Their tides can carry our penultimate thoughts. Wilkie Collins wrote a novel called *No Name* in Aldeburgh and it used to make me apply it to the seas in general.

Of course, like everyone else, I knew what George Crabbe thought of the German Ocean. His son was careful to write it down:

The only great object of nature that appeared to strike him was the SEA. This had been the commanding sublimity of his childhood, and once in after-life, having been deprived of a sight of it for a considerable time, he rode sixty miles and back merely for the pleasure of beholding it, and enjoying one plunge into its waves. This is the only

impulse of a poetical character to be met with in his career!

Edward FitzGerald saw the sea for the first time at Aldeburgh – 'My old mumbojumbo sea'. He said that it redeemed Suffolk from dullness! He would lie by the mainmast of his schooner-yacht named *The Scandal* reading the *Odyssey*. Best of all, he sailed away with the beautiful Posh on a herring-lugger named *The Meum and Tuum* (*The Mum and Tum* to Suffolk). Posh was 'broader and taller than all the rest; fit to be a leader of men, Body and Soul, looking now Ulysses-like'.

At first I thought that to 'look' at the sea was a landsman's compulsion. Britten watched it all the time. Although I cannot recall his ever mentioning it. When visitors stood on the sea wall to watch him working he had to move to where he had to take a long view of it. A pearly distance was – the sea! It possessed its own talk. Tucked into a windbreak I would listen to a commotion of shouts and barks, birdsong, and little floating pennants of distant conversation. Up by the Martello the rigging of the Yacht Club could be orchestral. Fitted naked into the accommodating shingle on an August afternoon, I should have been writing, notebook and pencil being so near. But usually I did nothing. I listened. It was why I came there.

Selected Personalia

J. R. ACKERLEY 1896–1967
Writer and editor.

(SIR) MALCOLM ARNOLD 1921–2006
Composer, whose works included symphonies and
music for brass bands.

JOHN BENSUSAN-BUTT 1911–1997
Artist and historian. Lived in the Minories,
Colchester.

ELIZABETH BOWEN (CBE) 1899–1973
Irish novelist and short-story writer loosely associ-
ated with the Bloomsbury Group.

**(LORD) BENJAMIN BRITTEN (OF ALDEBURGH,
OM, CH)** 1913–1976
Composer, conductor and pianist. Co-founder of the
Aldeburgh Festival. Partner of Peter Pears.

EDWARD CLODD 1840–1930
Banker, writer and anthropologist with a large circle
of scientific and literary friends.

GEORGE CRABBE 1754–1832
Clergyman, poet (*The Borough*) and surgeon.

ERIC CROZIER 1914–1994
Theatre director and opera librettist associated
with Benjamin Britten, with whom he co-founded

the Aldeburgh Festival. Married mezzo-soprano
Nancy Evans OBE in 1941.

EDWARD FITZGERALD 1809–1883
Poet and writer. Translator of the *Rubáiyát*.

E. M. (EDWARD MORGAN) FORSTER 1879–1970
Writer and librettist.

DAVID GASCOYNE 1916–2001
Surrealist poet.

(SIR) PETER HALL (CBE) 1930–
Theatre and film director. Directed *Akenfield*, based
on Ronald Blythe's *Portrait of an English Village*.

MAGGI HAMBLING 1945–
Painter and sculptor.

JAMES HAMILTON-PATERSON 1941–
Writer. Author of *Gerontius*, an imagined
reconstruction of Sir Edward Elgar's journey
along the Amazon in 1923.

GUSTAV HOLST 1874–1934
Composer.

IMOGEN HOLST 1907–1984
Composer, conductor, musicologist and encourager
of amateur musicians. A close friend of Benjamin
Britten and the daughter of Gustav Holst.

KURT HUTTON 1893–1960.
Pioneering German-born photographer.

M.R. (MONTAGUE RHODES) JAMES 1862–1936
Scholar of medieval history and writer of
ghost stories.

Selected Personalia

JOHN LEHMANN 1907–1987

Poet and literary editor, founder of *New Writing* and the *London Magazine.*

ARTHUR LETT-HAINES 1894–1978

Surrealist sculptor and painter. With Cedric Morris established the East Anglian School of Painting, first at Dedham and later at Benton End, Hadleigh.

ALUN LEWIS 1915–1944

Welsh poet, known particularly for his war poetry.

HEPHZIBAH MENUHIN 1920–1981

American-Australian pianist, writer and human-rights campaigner.

(SIR) **CEDRIC MORRIS** 1889–1982

Welsh painter and plantsman.
See also Arthur Lett-Haines, above.

JOHN NASH (CBE RA) 1893–1977

Artist and engraver. Lived with his wife Christine at Bottengoms, Wormingford.

CONRAD NOEL 1869–1942

Priest of the Church of England, Vicar of Thaxted. Founding member of the British Socialist Party and a friend of Gustav Holst.

GLENCAIRN STUART OGILVIE

Scottish writer, barrister and eccentric architect.

MERVYN PEAKE 1911–1968

Writer, artist, illustrator and poet.

(SIR) **PETER PEARS** (CBE) 1910–1986

Tenor. Partner of Benjamin Britten, with whom

he co-founded the Aldeburgh Festival and established
a long-standing recital partnership. Created many
roles in Britten's operas, including Peter Grimes
and Captain Vere (*Billy Budd*).

WILLIAM PLOMER 1903–1973
South African and British writer and literary editor.
In later years was to write librettos for Britten.

MARY POTTER 1900–1981
Artist and close friend of Benjamin Britten and Peter
Pears. Lived at the Red House in Aldeburgh, before
exchanging Aldeburgh houses with Britten and Pears.

REX PYKE 1940–
Film editor and producer of drama and documentary.

VIKRAM SETH 1952–
Indian novelist and poet.

MARTIN SHAW (OBE FRCM) 1875–1958
Prolific composer, conductor and producer.

PEGGY SOMERVILLE 1918–1975
Child prodigy and Impressionist painter.

SYLVIA TOWNSEND WARNER 1893–1978
Novelist, poet and translator.

CHRISTINE WESTON 1905–1989
British Indian writer, author of *Indigo*.

Bibliography

Aldeburgh Festival Programme Books, 1948–60

Burrows, Jill, *The Aldeburgh Story*, The Aldeburgh Foundation, 1987

Clodd, Edward, *Memories*, Watts, 1926

Forster, E. M., *Alexandria: A History and a Guide*, Morris, 1938

Furbank, P. N., *E. M. Forster: A Life*, Secker and Warburg, 1977

Grogan, Christopher (ed.), *Imogen Holst: A Life in Music*, Boydell Press, 2007

Hamilton-Paterson, James, *Gerontius*, Macmillan, 1987

Lago, Mary, and P. N. Furbank, *Selected Letters of E. M. Forster*, Collins, 1985

Liddell, Robert, *Cavafy: A Critical Biography*, Duckworth, 1974

Lummis, Trevor, *Occupation and Society: The East Anglian Fishermen*, CUP, 1985

Morphet, Richard, *Cedric Morris*, Tate Gallery, 1984

Osman, Colin, and Peter Turner, *Creative Camera International Year Book 1976*

Parkes, W. H., *Thorpeness*, Meare Publications, 2001

Powell, Neil, *George Crabbe: An English Life 1754–1832*, Pimlico, 2004

Weston, Christine, *Indigo*, Collins, 1946

Whitehead, R. A., *Garretts of Leiston*, Marshall, 1964

Winn, Arthur T., *Records of the Borough of Aldeburgh: The Church*, Austin, 1926

— *The Order Book 1549–1631*, Austin, 1925

Index

Abbo of Fleury, 132
Abingdon, 24, 46
Ackerley, J. R., 151, 241
Acton, 70
Æ (George William Russell), 84
Alde, River, 69, 129, 161, 230
Aldeburgh, 3, 7, 10, 13–16, 19–20,
 22–4, 26, 31–4, 36–7, 70, 80,
 83–6, 95, 114–15, 118–20, 124,
 139–42, 145, 147, 149–51, 157–8,
 161, 163–5, 170, 172, 174–5, 179,
 183–5, 189, 196–7, 201, 205,
 209–10, 213–14, 231–2, 235–6,
 238–40
 4 Crabbe Street (Crag House), 19,
 73, 81–2, 87, 115–16, 119
 36 Crag Path, 139–40
 Alde House, 14, 37
 Baptist Chapel, 119, 161
 Barclays Bank, 79, 87
 Brown Acres, 95
 Brudenell Hotel, 35
 Brudenell House, 80, 119, 121,
 131, 139–40, 147
 Crag Path, 36, 93, 121, 142, 155
 High Street, 36, 78, 82, 118, 119,
 125, 190
 Jubilee Hall, 26, 37, 115, 119
 Martello Tower, 12, 26, 31, 34–5,
 240
 Moot Hall, 36–7, 99, 119, 189–91,
 194, 197
 Order Book for 1549–1631, 172–5
 Red House, 82, 92, 244
 Strafford House, 155–7, 160,
 162–4
 Town Steps, 26
 Uplands Hotel, 169–71
 Wentworth Hotel, 81, 116–17,
 171
 White Lion Hotel, 2035
Aldeburgh Festival, 14, 15, 23, 36,
 71, 75, 79–81, 83, 87–8, 93, 99–
 100, 103, 113, 119–20, 140, 142,
 143, 149–51, 155, 241, 242, 244
 Council, 15, 99
 Executive Committee, 114
 Programme Books, 12, 23, 81, 92,
 113, 133
Aldeburgh Marshes, 129, 160
Aldeburgh Parish Church (St Peter
 and St Paul), 15–16, 76, 82, 99,
 119, 121, 164, 169, 175, 183
 Britten memorial window, 15
Aldeburgh Parish Register, 8
Aldeburgh Public Library, 33
Aldeburgh Yacht Club, 34, 240
Alexandria, 23–4
Algarve, 204
Anderson, Skelton, 37
Arnold, Malcolm, 185–6, 241
Arnold, Matthew, 64, 160
Artists' Rifles, 45
Arts and Crafts Movement, 106,
 109
Athelstan, 132
Athenaeum, 161
Atkinson, Anthony, 172
Austen, Jane, 60, 179

Bach, Johann Sebastian, 110, 111,
 115, 122
 Komm, Jesu, Komm, 101
Baggott (newsagent), 87
Bailey, Rosie, 157–8
Bali, 113

Ball, Hugo, 146
Ballingdon, 50
Balliol College, Oxford, 88
Barnett, Canon John, 109–11
Barrie, J. M., 9–10
 Peter Pan, 10
Barton, Bernard, 215
Barton, Lucy, 215, 216
Bawden, Edward, 64
Bax, Arnold, 110
BBC, 65, 84
Beatles, 228
Beaumont, Winifred, 60
 The Key, 60
Becker, Georgina, 194
Becker, Harry, 192–5
Beech, Mrs (Aldeburgh), 125
Beeny Cliff, 164
Behan, Brendan, 129
Bell, Adrian, 49–51
 The Cherry Tree, 50
 Corduroy, 50
 Men and the Fields (with John
 Nash), 50
 Silver Ley, 50
Belsen concentration camp, 139, 140
Benham's (printer), 113
Benson, E. F., 170, 175
Bensusan, S. L. 112
Bensusan-Butt, John, 112, 193, 241
Benton End, *see* Hadleigh
Berenson, Bernard, 191
Berlin, 140, 141
Betjeman, John, 165
Beveridge Report, 183
Blake, William, 73
Bloomfield, Robert: *The Farmer's
 Boy*, 196
Bloomsbury Group, 241
Blow, John: *Venus and Adonis*, 114
Blyth, River, 102, 230
Blyth Hundred, 194
Blythburgh, 99, 101–2
Blythburgh Church (Holy Trinity),
 88, 97, 99, 102–6, 169
Blythe, Ronald, *1, 211*
 Akenfield, 86, 89–90, 92–3, 196,

219, 237, 242
Aldeburgh Anthology, 75–6, 92–3
Guide to Aldeburgh Parish
 Church, 15, 165–6
 A Painter in the Country, 65
 A Treasonable Growth, 26–7, 73
Bonnard, Pierre, 148
Borley, 181
 Rectory, 180
Borneo, 72
Borrow, George, 31
Botolph, St, 94
Botteghe oscure, 9
Bottengoms, *see* Wormingford
Boulge, 219, 221, 222, 227
Boulge Church, 218
Bowen, Elizabeth, 3, 20, 241
 A World of Love, 184
Boxted, 53
Brandon, Charles, Duke of Suffolk,
 132–3
Braybrooke, Mr (Rector of Boulge),
 218–19
Bream, Julian, 74
Bresson, Robert, 89
Breton, André, 140
Brett, River, 69, 201
Bridge, Frank, 110
British Museum, 114
Britten, Benjamin, 8, 11, 15, 19–23,
 37, 71, 74–6, 77, 79–84, 88–90,
 92–5, 99–100, 105, 109, 112–13,
 115–16, 118–21, 123–5, 130, 144,
 145, 151–2, 158, 164, 166, 169,
 184–5, 191, 223, 236–7, 240–44
 Albert Herring, 92, 114
 Billy Budd, 23, 244
 Curlew River, 94
 Death in Venice, 95
 Gloriana, 112–13, 124
 Let's Make an Opera, 73, 76
 A Midsummer Night's Dream, 88
 Noye's Fludde, 82, 125
 Peter Grimes, 21–3, 120, 244
 The Rape of Lucretia, 15
 Saint Nicolas, 76, 169, 171
 Songs from the Chinese, 74

The Turn of the Screw, 183
Winter Words, 164
Brooklands motor-racing circuit, 44
Browne, William, 220
Brown's Hotel, 208
Brücke, Die, 145
Bulmer, 181
Bures, 50, 59, 65
Burke, Edmund, 7, 8
Burma, 238
Bury St Edmunds
 St Edmundsbury Abbey, 133
 St Mary's Church, 133
Butley, 129, 130

California, 21
Cambridge, 39, 150
Cambridge University, 13, 39
Camus, Albert, 20
Canterbury Cathedral, 105–6
Canvey Island, 35, 81
Carlisle, 91
Carlisle Cathedral, 216
Carlyle, Thomas, 222
Cartier-Bresson, Henri, 140
Catchment Board, 35
Cavafy, C. P., 23–6
 'The God Abandons Antony', 25
 'Ithaca', 24, 26
Chamber's Journal, 3
Chaucer, Geoffrey, 105
 Troilus and Criseyde, 105
Chapman and Hall (publishers), 160
Charsfield, 95, 222
Chartres Cathedral, 105
Chelsea School of Art, 88
Chesil Bank, 12
Chillesford, 129
Chilterns, 44, 46, 62
Churchill, Winston, 183
Clare, John, 196, 203
Clark, Sir Kenneth, 191
Claudius, Emperor, 91
Clemens non Papa, Jacobus: *Sanctus*, 121
Clodd, Edward, 155–65, 241
 The Childhood of the World, 160

Memories, 156–7
Clodd, Phyllis, 155–7, 163
Colchester, 12, 43, 44, 52, 60, 80, 85, 91, 101, 113, 193, 201
 Minories, 60, 193, 241
Colchester Art School, 56
Colchester Castle, 90–91
Colchester Pageant (1909), 44
Collins, Wilkie: *No Name*, 239
Constable, John, 45, 50, 80, 196
Constantine Bay, 186
Cook, Sir Francis, 79–80
Copinger, Walter, 103
Cornwall, 4, 48, 61, 64, 164, 183–5, 202, 204, 214, 235, 238, 239
Corsica, 34
Cotman, John Sell, 49
Courtenay, Ashley: *Let's Halt Awhile in Britain*, 170–71
Cowell, Edward, 213
Crabbe, George, 7, 8, 14–16, 21–2, 34, 36, 69, 71–2, 170, 172, 189, 191–2, 197, 239–40, 241
 The Borough, 14, 16, 21–2, 191–2, 196, 241
 The Village, 196
Crabbe, George (son), 7, 8, 196, 215
Cragg Sisters (restaurant), 87, 120
Craig, Edward Gordon, 149
Cranbrook, Fidelity, Countess of, 69–70, 73, 75, 76, 80–81, 83, 143, 215
Cranbrook, Jock, Earl of, 70–73, 81
Craxton, John, 152
Crompton, Richmal: *Just William*, 10
Crossman, Richard, 145
Crozier, Eric, 37, 75–6, 241
Cullum, Mr (bank manager), 79, 83, 87
Cullum, Jeremy, 79
Currey, R. N. (Ralph), 84, 85
Cuthbert, St, 142
Cuyp, Aelbert, 88

Dallinghoo Wield, 215, 228, 232
Darend, Sir Mortimer, 217

Dartington, 115, 118, 120, 124
Daumier, Honoré, 191
David (Wormingford farmworker), 195
David, Elizabeth, 204
Davy (Debach), 220–21
Day-Lewis, Cecil, 180
Dearmer, Percy, 150
Death, Mr (postman), 52
Debach, 196, 216, 219, 222, 227–8, 230, 231–2
 Airfield, 222, 223, 227
 French's Folly, 215, 232
Debach Enterprises, 223
Deben, River, 229, 230
Dedham, 243
Delafield, E. M.: Diary of a Provincial Lady, 10
Dennington, 105
Dephot, 146
Derbyshire, 64
Dickens, Charles, 182
Doncaster, Mary, 59
Dorchester, 158
Duffy, Eamon, 104
Dugdale, Florence, see Hardy, Florence
Dukes, Ashley: The Dumb Wife of Cheapside, 174
Dunstan, 132
Dunwich, 229
Duparc, Henri, 110
Durham Cathedral, 142

East Anglian School of Drawing and Painting, 202, 243
East Coast flood (1953), 35, 81, 83
Eastbourne, 235
Eden, Sir Anthony, 172
Edmund, St, 132
Eleanor of Aquitaine, 106
Elgar, Edward, 242
 Symphony No. 1, 95
Elliott, Clarence, 49
English Folk Dance and Song Society, 46
Eric (Wormingford neighbour), 189

Essex, University of, 101
Eustace-Smith family, 59
Evans, Nancy, 75, 76, 242

Faber Music, 93
Fanthorpe, U. A., 157–9
 'Very Quiet Here', 158–9
Farmer, Hugh, 133
 A Cottage in the Forest, 133–4
Fawcett, Millicent, 13
Fens, the, 150
FitzGerald, Edward, 33, 38, 196–7, 213–23, 231, 240, 242
 The Rubáiyát of Omar Khayyám, 213–14, 217, 242
Fitzgerald, F. Scott: Tender is the Night, 182
Flaherty, Robert J., 89
Flatford, 56
Flatford Mill Field Studies Centre, 56, 142, 144
Fletcher, Posh, 214–15, 240
Florida, 235
Foljambe family, 4, 9, 11
Ford, Ford Madox, 60
Ford, Captain William, 34
Forster, E. M., 3, 17, 19–24, 26, 80, 115–18, 161, 242
 Alexandria: A History and Guide, 23–4
 The Hill of Devi, 117–18
 Marianne Thornton, 20, 80
Fowler, Robert, 175
Fox, George, 91
Framlingham, 43, 48, 82, 135, 160
 Crown and Castle, 160
French, Harold, 215, 221, 223
Friends House, Euston Road, 91
Friends Meeting House, Bury St Edmunds, 91
Friesz, Othon, 207
Fry, Roger, 191, 206
Furbank, P. N., 163

Gainsborough, Thomas, 44–5
Gallipoli, 13
Garcia Three, 181

Index

Garrett, Denis, 11, 12, 14, 36, 39, 81, 94, 130, 131, 150–51, 171, 190

Garrett, Frank, 13

Garrett, Jane, 11, 14, 39, 94, 130, 150–51, 171, 192

Garrett, Newson, 13, 36, 38–9, 170, 172

Garrett Anderson, Elizabeth, 13, 14, 39, 190, 192

Garrett family, 192, 194

Gascoyne, David, 101, 242
 Paris Journals, 101
 'Sentimental Colloquy', 101–2

Gathorne-Hardy family, 49, *68*, 71, 73, 76

George VI, 151

Gestingthorpe Hall, 60

Girtin, Thomas, 49

Gissing, George, 156, 161

Glyndebourne Festival Opera, 92

Godfrey, Rupert, 15–16, 165, 169, 175

Gordon Riots, 7

Gospel According to St Matthew, The (film), 89

Gothenburg, 238

Gouldthorpe, George, 123

Gower peninsula, 44

Grant-Duff, Miss (Aldeburgh), 155–7, 163

Great Glemham, 49, 70, 89, *211*, 215

Great Glemham House, 69, 73, 75

Gregory, Lady, 84

Grigson, Geoffrey, 13

Guedalla, Philip, 111

Guevara, Che, 228

Guttmann, Simon, 144–7

Hadleigh, 36, 56, 64, 144, 202, 209
 Benton End, 64, 101, 184, *199*, 201–6, 208–10, 243

Hadleigh Church, 190

Haggard, H. Rider, 193
 Rural England, 86

Hahn, Reynaldo, 110

Haines, Arthur Lett- (Lett Haines), 64, 184, 201–8, 243

Hale, Kathleen, 205
 Orlando the Marmalade Cat, 205

Hall, Peter, 89, 92, 95, 242

Hambling, Maggi, 8, 13, 70, 205, 242
 Britten memorial, 13

Hamilton, Ian, 85

Hamilton-Paterson, James, *225*, 227–31, 235, 242
 Gerontius, 242
 Playing with Water, 228

Hardy, Emma, 164, 185

Hardy, Florence, 164

Hardy, Kate, 157

Hardy, Thomas, 38, 89, 156–8, 159–65, 185, 193, 195
 'The Convergence of the Twain', 157
 A Pair of Blue Eyes, 163–4
 The Poor Man and the Lady, 160

Harewood, Earl of, 83

Hartley, L. P., 60

Heaney, Seamus, 101

Helpstone, 196

Hemingway, Ernest, 203

Hemsley, Thomas, 116

Henry VIII, 132–3

Herbert, George, 75, 84, 146, 171

Hickson, Guy, 59

Hickson, Joan, 59

Hitler, Adolf, 34

Hollesley, 129

Holst, Gustav, 109–12, 114–16, 123, 242, 243
 The Planets, 112
 Savitri, 114–16
 'Turn back O man, forswear thy foolish ways', 114

Holst, Imogen, 43, 46, 75–6, 84, 86–7, 90, 92–3, 95, 100–101, *107*, 109–10, 112–24, 140–41, 144–5, 150, *155*, 163, 169–71, 174, 216, 223, 237, 242

Homer: *The Odyssey*, 240

Honegger, Arthur: *King David*, 118

Hopkins, Gerard Manley: 'God's

Grandeur', 149
Hopkinson, Tom, 146
Howe, Miss (Aldeburgh), 33, 38
Howe, Miss (Woodbridge), 223
Howells, Herbert, 110
Hudson, Elizabeth (Nellie), 87, 120, 121
Hudson, Stephen, 130
Hughes, Ted, 101
Huinzinga, Johan, 106
Hutton, Gretl, 139, 141–2, 144, 147, 150–51
Hutton, Kurt, 15, 71, 88, 93, 113, 139–47, 150–51, 204, 210, 242
Hutton, Peter, 142
Hutton, Sebastian, 142
Hutton family, 137
Huxley, Julian, 239
Huxley, T. H., 161

Iken, 39, 94
Illustrated London News, 218
Ipswich, 105, 114, 157, 192, 213, 220, 231, 232
Ireland, John, 110
Iver Heath, 47
Ixion, 203

Jacob, John, 93
James, Henry, 60, 183
 The Spoils of Poynton, 60
 The Turn of the Screw, 183
James, M. R., 103, 183, 231, 242
Jefferies, Richard, 31
Job, The Book of, 22
Joint Stock Bank, 161, 163
Journal of the Folk-Song Society, 123

Kent, 182
Kessingland, 34
Keyes, Sidney, 143
Khayyám, Omar, 217, 219
King's Marshes, 129
Kokoschka, Oskar, 118
Kühlenthal, Christine, see Nash, Christine

Laden, Juliet, 11, 79–80, 119, 121, 131, 139, 147–50, 155
Laden, Leon, 88, 139, 143, 147–9, 151
Land's End, 239
Langland, William: Piers Plowman, 194
Langston, John, 55
Lantern Marshes, 129
Lark, River, 69
Larkin, Philip: 'Church Going', 103
Lawrence, D. H., 203, 239
Lear, Edward, 47
Lee, Laurie, 7
Léger, Fernand, 207
Lehmann, John, 9, 243
Leiston, 11, 147, 150, 192, 194
Leiston Ironworks, 13, 150
Lett-Haines, Arthur, see Haines, Arthur Lett
Lewis, Mr (Wormingford), 53
Lewis, Alun, 229, 237–8, 243
Lhote, André, 207
Ling, Bob, 94
Ling, Doris, 94
Linnet, River, 69
Listener, 21
Little Easton, 110
 Rectory, 109, 112
Little Gidding, 142, 144, 146
Liverpool Street station, 145, 165
London Group, 207
London Magazine, 3, 79, 80, 243
Long Melford, 36
Long Melford Church, 104
Lorent, Stefan, 146
Loretto, 9
Lowestoft, 11, 236–7, 238
Lubeck, 88

Mabey, Richard, 130
Macaulay, Rose: The Towers of Trebizond, 184–5
McCabe, Joseph: Edward Clodd, 156
Macmillan (publishers), 163
Mahabharata, 116
Man of Aran (film), 89

Index

Mandikian, Arda, 116
Mann, Mary: *Tales of Dulditch*, 193
Mann, Thomas: *Confessions of Felix Krull*, 184
Mary Tudor ('the French queen'), 132–3
Massenet, Jules, 110
Matterhorn, 162
Mayakovsky, Vladimir, 146
Maypole Hill, 215, 230
Meadle, 49, 51
Mehalah, St Osyth, 59
Menuhin, Hephzibah, 74, 243
Meredith, George, 38, 156, 160, 161
Millet, Jean-François, 190–92, 194–5
 The Angelus, 190–91
Millie (Benton End housekeeper), 205
Minton, John, 152
Mitchell, Donald, 90
Montagu-Pollock, Sir William, 48
Moore, George, 84
Morgan, Glyn, 205
Morphet, Richard, 209
Morris, Sir Cedric, 56, 64, 81, 101, 142, 144, 152, 184, *199*, 201–10, 243
Morris, William, 105–6, 113–14
Moscow, 146
Mozart, Wolfgang Amadeus, 83, 110, 236
 Idomeneo, 88
Mundesley Sanatorium, 44
Munich, 114
Murdoch, Iris: *The Flight from the Enchanter*, 185

Naishapur, 217
Napoleon Bonaparte, 34, 35
Naseby, 223
Nash, Barbara, 46, 48
Nash, Christine (née Kühlenthal), 5, 38, 43–6, 48–9, 51–2, 54, 57–61, 64–5, 73, 80–81, 84, 86, 120, 140, 216, 243
Nash, John, 12, 15, *42*, 43–51, 54–

66, 81, 90, 95, 113, 130, 132, 142, 152, 201, 205, 243
 Aldeburgh Beach, 233
 The Cornfield, 55
 Men and the Fields (with Adrian Bell), 50
 Sea Holly, 29
 Staverton Thicks, 127
Nash, Paul, 44, 46, 47, 63
Nash, William (John Nash's father), 46, 47
Nash, William (John Nash's son), 49
Nayland, 6, 53
Neue Club, 145
New South Wales, 142
New Statesman, 3
New Writing, 243
Newby, P. H.: *Picnic at Sakkara*, 184
Newdigate Prize for Poetry, 228
Newlyn, 238
Newlyn School, 239
Newmarket, 142, 144, 219
Newnham College, Cambridge, 13–14
News of the World, 10
Nichols, Norah, 37, 38
Nichols, Robert, 31, 37
Nizami, Kwajah, 217
Noel, Conrad, 110, 243
Norfolk, 5, 47, 193

Oates, Miss (Gestingthorpe), 60
Oates, Captain Lawrence ('Titus'), 60
O'Brien, Conor Cruise, 85
Ogilvie, Glancairn Stuart, 9, 10, 243
 The Meadows of Makebelieve, 10
Oram, Canon (Aldeburgh), 165
Ore, River, 129
Orford, 13, 34, 129, 131, 151, 191, 237, 238
Orford Castle, 129
Orford Church (St Bartholomew), 82
Orwell, River, 230
Oxford Book of Carols, The, 150
Oxford University, 142, 151

Palestrina, Giovanni, Pierluigi da:
 Stabat Mater, 100
Palmer, Samuel, 215
Parham, 197
Paris, 191, 202–4, 207
Parnell, James, 90–92
Pasolini, Pier Paolo, 89, 92
Peake, Maeve, 182
Peake, Mervyn, 181–2, 184, 243
 The Glassblowers, 182
 Gormenghast, 136, 181
 Titus Groan, 181, 184
Pears, Sir Peter, 21, 37, 74, 75, 77,
 80–81, 92–4, 113, 116, 145, 149,
 151–2, 164, 219, 241, 243–4
Peasenhall, 31
Pellew, Claughton, 47, 48
*Penguin Companion to English
 Literature, The*, 213–14
Penzance, 213
Perkins, Christopher, 180–81
Perkins, Juliet, *see* Laden, Juliet
Perkins's Diesel Engines, 150
Petrie, Flinders, 160
Pevsner, Nikolaus, 103
Philippines, 230
Picture Post, 139, 146, 151
Piper, John, 15
Pissarro, Lucien, 193
Plomer, William, 85, 244
Plotinus, 23
Po Chu-i: 'The Temple', 75
Pollock, Sir Frederick, 161
Portugal, 209
Potter, Mary, 73, 82, 244
Potter, Stephen, 82
Powell, Flo, 109
Powell, Neil, 8
Primrose Cottage (Turner home),
 185
Pritchett, V. S., 3
Pritt, Lyn, 117
Proust, Marcel, 130–32, 164
 Remembrance of Things Past, 110
 Time Regained, 130–32
Purcell, Henry, 100
 Magnificat, 100–101

Timon of Athens, 121
Purcell Singers, 100
Pyke, Rex, 89, 92, 244

Rainier, Priaulx: *Requiem*, 101
Rationalist Press Association, 163
Ravilious, Eric, 58
Read, John, 65
Redstone, Miss (librarian), 33
Reiss, Beth, 87
Reiss, Stephen, 80–81, 83, 87–8,
 100, 109, 113, 148, 193
Rendham, 69
Repton, Humphrey, 69
Retford, 91
Rilke, Rainer Maria, 147
Robertson, Grace, 147
Rodgers, Marianne, 84
Rodgers, W. R. ('Bertie'), 84–6, 155
Rome, 105, 204
Rope, Phyllis, *see* Clodd, Phyllis
Rope family, 16
Ross, Angus, 213
Royal Academy School, 139
Royal College of Art, 56
Royal College of Music, 207
Rye, 175

Sackville-West, Edward, 21
Saffron Walden, 157
 Fry Gallery, 157
St Austell, 65
St Juliot, 164
St Petersburg, 9
Salzburg, 83
Sansom, William, xiii
Savile Club, 161
Schiff, Sidney, 130, 131
Schleswig-Holstein, 88
Schubert, Franz, 114, 206
Scotland, 61, 130
Scott Moncrieff, Charles, 130
Seaside Bungalows Ltd, 11
Seth, Vikram, 6, 244
Seven and Five, 207
Shakespeare, William, 219
 The Merry Wives of Windsor, 12

The Tempest, 172
Sharp, Cecil, 46
Shaw, Martin, 149–50, 244
 'God's Grandeur', 149, 151
Shelburne, Lord, 7
Shingle Street, 231, 238
Shropshire, 64
Sickert, Walter, 45
Six Hills Nursery, Stevenage, 49
Sizewell, 4
Sizewell nuclear power station, 8
Skye, 65
Slade School of Fine Art, 45, 47, 58
Slater, Montagu, 22
Slaughden, 34, 129, 149
Snape, 38, 88, 94, 192
 Maltings, 13, 38–40, 88, 172
 Mill, 11
Snape Maltings Concert Hall, 39,
 88, 92, 94, 125
Snape Maltings Foundation, 90
Socialist Party, British, 243
Solomon (pianist), 111
Somerville, Peggy, 88, 119, 121,
 131, 139, 147–9, 244
Southwold, 5, 37
Spooner, H. W. (housepainter), 53
Stanislavsky, Konstantin, 149
Staverton Park, 134
Staverton Thicks, 130, 132–6
Stein, Erwin, 144
Stein, Gertrude, 203
Stein, Sophie, 144
Steinbeck, John: *East of Eden*, 194
Stephen, Sir Leslie, 161
Stevenson, Robert Louis: *Treasure
 Island*, 10
Stoke-by-Nayland, 46
Stour, River, 50, 65, 146, 201, 230
Stour Valley, 45, 48–50, 195
Stratford St Andrew, 162
Stravinsky, Igor: *The Soldier's Tale*,
 114
Sudbourne Marshes, 129
Sudbury, 50, 180
Suez crisis (1956), 151, 172, 183
Summerhill School, 147

Sutton Hoo, 229
Sweeting, Elizabeth, 79–81, 83

Tagore, Rabindranath, 115
Tate Gallery, 55, 209
Taylor, Joseph, 123
Tehran, 217
Tennyson, Alfred, Lord, 214, 222
 In Memoriam, 31
Tennyson, Sir Charles, 31
Tennyson, Hallam, 31
Tennyson, Julian, 31–3, 35, 38, 103
 Suffolk Scene, 31–3
Thakar, Pandit Onkaamda, 115
Thaxted, 43, 109–14, 243
 Monk Street Cottage, 112
 The Steps, 112
Thomas, Dylan, 3
Thompson, Revd Arthur, 99–100
Thorpeness, 4, 6–11, 13, 21, 31, 37,
 143, 237
 Dolphin, 10
 Fairhaven, 19
 House in the Clouds, 10
Times, The, 146
Tippett, Michael: *Fantasia Concer-
 tante on a Theme of Corelli*, 95
Tomkins, Thomas: *O Pray for the
 Peace of Jerusalem*, 101
Tradescant, John, 54
Tuohy (estate agent), 86
Turner, Cathy, 179, 183–4, 186
Turner, James, 11, 36, 84, 86, 111,
 130, 164, *177*, 179–86, 239

Unwin, Francis, 44

Van Gogh, Vincent, 191
Vaughan Williams, Ralph, 110, 150
Venison, Tony, 209
Verdun, 142
Victoria, Queen, 37
Vienna, 140, 145
Voltaire, Club, 146

Walberswick, 99
Waley, Arthur, 74–5

Warner, Sylvia Townsend, 219–20, 244

Warwick, Countess of (Frances Maynard), 110–11

Wash, the, 35, 81

Waterloo, Battle of, 34

Waveney Valley, 193

Weaver, Nigel, 157

Weight, Carel, 64

Welford, B. (housepainter), 53

Welford, Beth, 236–7

Wells, H. G., 111, 162–3
 Boon, 162–3

Westleton, 148

Weston, Christine, 4, 244
 Indigo, 4–6, 20, 244

Weybridge, 24

White, T. H., 219

Whymper, Edward, 161–2
 Scrambles Amongst the Alps, 161

Wicken Fen, 13

Wickham Market, 216

Winn, Arthur, 170, 172–5

Winn, Connie, 170–73, 175

Wissington, 49, 51–2
 Creems Farm, 49
 Fox Inn, 50

The Thatch, 50

Wittenham Clumps, 47

Wood, Dr Thomas, 59
 True Thomas, 59

Woodbridge, 130, 144, 214–15, 223, 227
 Bull Hotel, 215, 237

Wordsworth, William: *The Prelude*, 73

Workers' Educational Association, 110

Wormingford, 38, 43–6, 48–9, 51–2, 54, 58, 61–2, 64–6
 Bottengoms, 42, 43, 46, 48–9, 51–5, 58–60, 63, 65, 201, 205–6, 208, 243
 Dramatic Society, 58–9
 Village Hall, 58
 Wormingford Mill, 43–6, 48

Wray, George, 123

Yeats, W. B., 84

Zennor, 239

Zola, Émile, 193

Zurich, 146

لونو